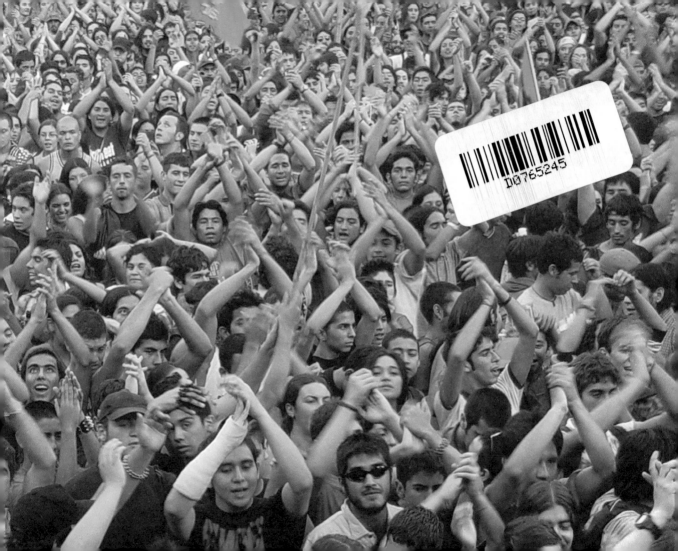

2/15

the day
the world
said NO
to war

2/15 – THE DAY THE WORLD SAID NO TO WAR

Conceived and created by CONNIE KOCH / Hello [NYC]
Photo Editing and Research MAREILE FRITZSCHE
Edited by BARBARA SAUERMANN
Copy Editing MAME McCUTCHIN
Publishing Director MARYANN CAMILLERI

With support from and thanks to United for Peace and Justice

Cover photograph by MICHALIS SOURLIS / nbpictures (London / 2.15.03)
Cover quote by PEACE PILGRIM
Endpaper photo by RAFAEL EDWARDS / ANTOJA ART COLLECTIVE (Santiago De Chile / 2.15.03)

First published in 2003 by

Hello [NYC]
216 East 6th Street
New York NY 10003
www.hellonyc.net

and

AK Press
674 A 23rd Street
Oakland CA 94612-1163
www.akpress.org

AK Press
PO Box 12766
Edinburgh
Scotland
EH8 9YE
www.akuk.org

Additional copies of this book are available for $24.95 from AK Press. Please enquire about bulk discounts available for activists, peace groups, and campaigns.

Printed in China
ISBN 190259385-5

It's a shame that it takes a war to inspire people (myself included) to be politically creative. Maybe if we all got off our asses between wars and said something, we could give the next one a miss.

KEIRON O'CONNOR PHOTOGRAPHER

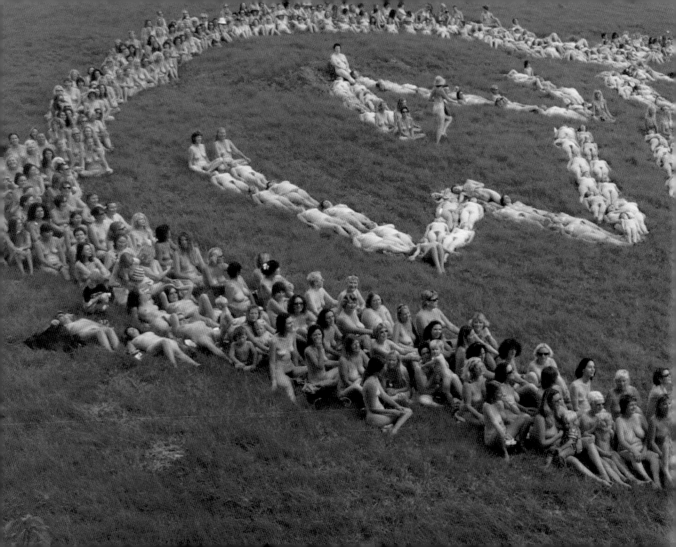

On February 15, 2003
the world changed once again.
An imminent war in Iraq
prompted a new protest
movement, uniting the
world in peace, for peace.
Political activism exploded
with marches and protests
in more than 100 nations
around the globe.

Up to 30 million people demonstrated worldwide, according to figures from organizers and police, although most conceded there were too many people in too many places to count. 2/15 marks the biggest global peace demonstration in the history of political activism.

The book 2/15 is a grassroots collection of photographs and artwork from the peace demonstrations on and around February 15th 2003, paired with a selection of critical statements from popular voices around the world.
As international and diverse as the demonstrations themselves, the images and ideas within 2/15

reveal opinions and questions beyond the Iraq crisis, while preserving the most captivating moments and messages from this historic movement for peace. Over 2,500 photographs, works of art, and quotes have been submitted from over 40 countries worldwide. Thanks to all contributors for lending their work and their voices to 2/15.

BAGHDAD
IRAQ
2.15.03
PHOTO BY
MARTIN SASSE
LAIF

STUDENTS OF SYRIAN DESCENT

IN MY EYES THE WORLDWIDE
PARTICIPATION AND INTERNATION-
ALITY OF THE NEW PEACE MOVEMENT
WAS MIRRORED ON THIS HISTORICAL
DAY IN THE HEART OF BAGHDAD:
COMMUNITIES FROM A MULTITUDE
OF ARAB NATIONS RESIDING IN
IRAQ PROTESTED AGAINST THE
WAR OF ATTRITION IMPOSED
ON THE IRAQI PEOPLE IN FRONT
OF THE UNDP HEADQUARTERS
AT ABU NUWAS ON THE BANK
OF THE TIGRIS.

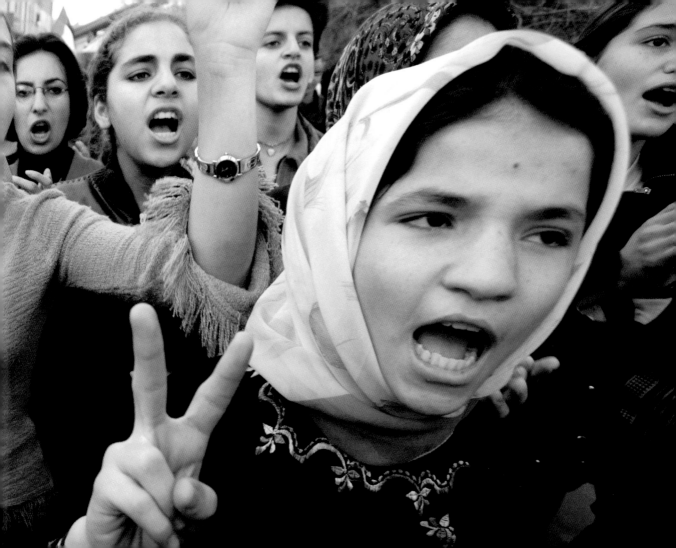

The Globalization of Peace

BY **ARUN GANDHI**
FOUNDER AND PRESIDENT, M.K. GANDHI INSTITUTE FOR NONVIOLENCE

2/15 marks the day we successfully globalized peace, the day when millions of anguished people poured out into the streets to express their frustration with violence and governments. This anthology of photographs and comments from people all over the world commemorates this momentous event.

2/15 became momentous because it is the first time in the recent history of the world that millions took a stand for peace. In the past, peace movements were nationalized so that only the people of the concerned countries expressed their opinions whilst the rest of the world passively watched. 2/15 marks the day when the people of the world came together to forge a Community of Peace.

Working for peace, however, has never been easy. It is made all the more difficult because many people think that peace means the absence of war, that peace

means to get people to stop fighting, that peace must come because we want it. The two important factors that we tend to ignore are peace cannot come when we harbor anger, hate, and violence in our hearts and secondly, peace work should not simply be a reaction to the work for war.

In other words, the connection between our thoughts and our destiny is very real and strong. If our thoughts are negative our destiny will also be negative. Mohandas K. Gandhi said that our thoughts determine what our words will be; our words will determine what our behavior will be; our behavior will determine what our habits will be; our habits will determine what our values will be and, finally, our values will determine what our destiny will be.

Is it then illogical to assume that if we wish our destiny to be peace it must begin with our thoughts – individual and collective? If our thoughts are filled with negativity, which is the bedrock of violence, then our destiny will also be violent.

Looking back at the history of human beings it becomes obvious that we have chosen to weave around us a culture of violence. This culture permeates every aspect of human life, which is why every time we face a conflict at any level our personal reaction is dictated by the culture of violence.

Both Gandhi and Tolstoy described the culture of violence as the Law of Force, a quick and convenient way to protect our manifold possessions. As individuals and as nations this Law of Force has become our mainstay.

The Law of Force, to be effective, must continuously be upgraded and escalated. So, as individuals the more possessions we have the more security we build around our homes. In the United States, for example, homeowners possess guns to protect their

families from intruders.

The consequence of this kind of culture of violence is that we, individually, are involved in a constant arms race one way or another. Since many individuals own guns in the United States the race is between criminals and citizens to see who has the more sophisticated weapons. In other countries the race is to see which is the best security system that ensures the safety of one's possessions. So, each is reacting to the other.

That reactionary mode seeps into all our actions. Our work for peace is also a reaction to a call for war. While on the one hand 2/15 marks the day when peace surged in the hearts of millions of people around the world on the other hand, sadly, it also marks a day of disappointment. Many millions are now disillusioned because they were not able to stop the United States from going to war. This is understandable.

As one who has seen and studied Gandhi's work in India I will venture to make a few observations with the utmost humility. For Gandhi the work for peace was a continuous action and it was only during the course of this work that he reacted to injustices whenever they occurred. He kept the people involved and informed and so frustration was at its lowest ebb. I think there is a message in Gandhi's experience for the modern day peace movement.

We can only understand and appreciate peace if we first understand the many facets of violence. It is not only governments and big business who practice violence against society but each one of us is consciously and unconsciously involved in doing violence to one another and to the environment. Growing up under the tutelage of my grandfather I was taught the art of introspection. Gandhi said we commit violence not only in the physical sense but more so in the passive

sense. The distinction between the two is that physical violence constitutes all acts of violence in which physical force is used while passive violence is just the opposite; it occurs when no force is used and yet it hurts people in a thousand different ways.

Every day I had to analyze my actions and put them down in the appropriate place on this tree of violence. Soon passive violence began to dominate physical violence which, according to my grandfather, is the fuel that ignites the fire of physical violence.

So, logically, if we wish to put out the fire of physical violence we have to first cut off the fuel supply. Thus, we must be the change we wish to see in the world. It has to begin with each one of us.

Life today is a sad commentary of people's lack of enthusiasm in the affairs of the nation so that only a small minority turns out to exercise its franchise. Most democratic governments around the world are, consequently, elected by a small fraction of its citizens and yet we, unhesitatingly, bestow upon our politicians such sweeping powers that in a matter of days they can commit hundreds of thousands of soldiers to a war they know nothing about. It is not for the soldiers to question why but to simply do or die.

In a democracy there appears to be no machinery that citizens can use to stop the perpetration of violence in their names. Like a docile animal that rolls over on its back and submits to a greater power, we, the citizens of the world, have similarly submitted ourselves docilely to politicians whom we elect to power and corporate giants who wouldn't be giants if we did not consume their products.

When Gandhi said, "No one can oppress you more than you oppress yourself," he knew the answer to our problem.

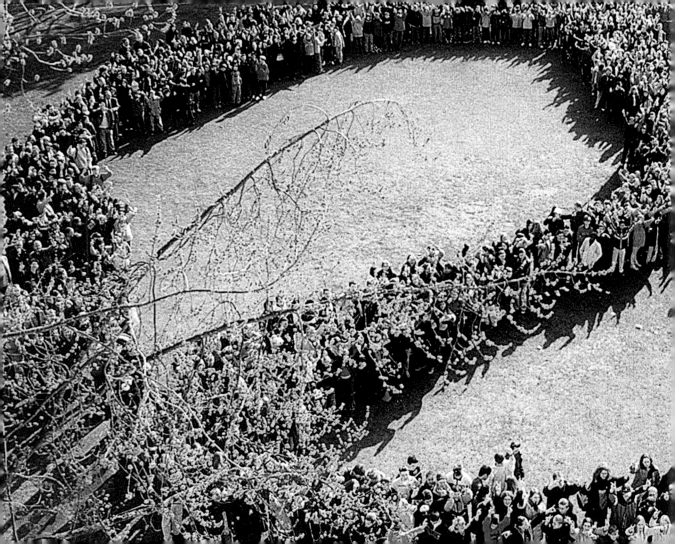

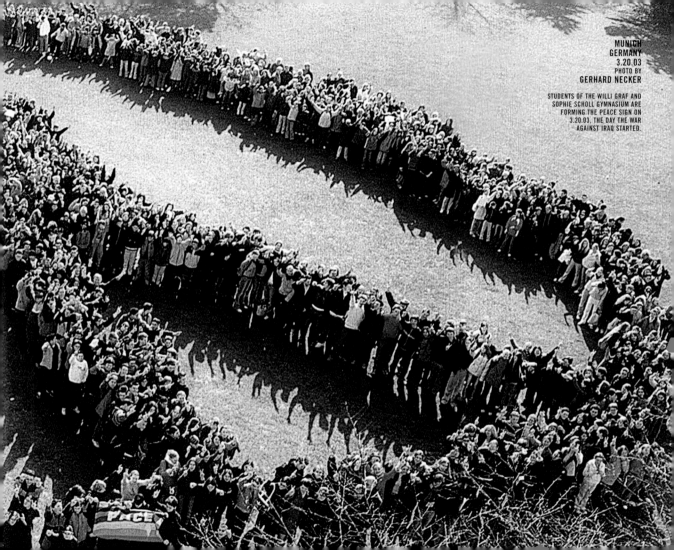

MUNICH
GERMANY
3.20.03
PHOTO BY
GERHARD NECKER

STUDENTS OF THE WILLI GRAF AND
SOPHIE SCHOLL GYMNASIUM ARE
FORMING THE PEACE SIGN ON
3.20.03, THE DAY THE WAR
AGAINST IRAQ STARTED.

Amsterdam

The artist Jeroen Buitenhuis performed
a site specific visual statement on the
Museum Square in Amsterdam. With the
help of 40 friends he produced 2000 white
cardboard crosses and installed them in
front of the American Consulate – the perfect
framework for this emotional protest.

WILLEM POELSTRA PHOTOGRAPHER

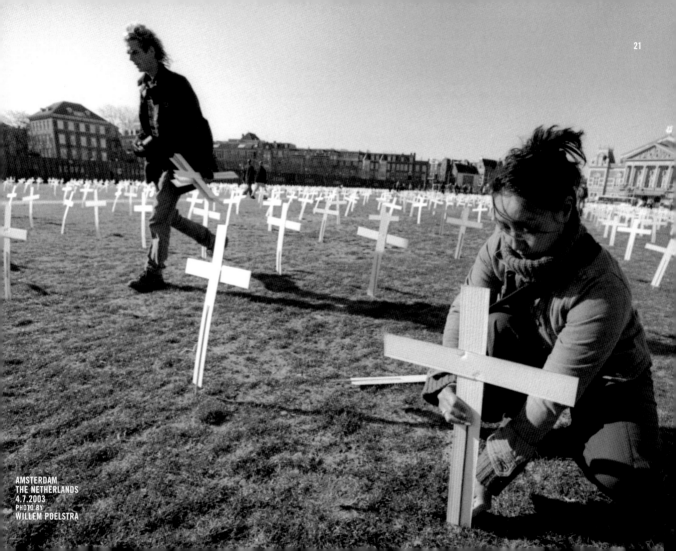

AMSTERDAM
THE NETHERLANDS
4.7.2003
PHOTO BY
WILLEM POELSTRA

Athens

The first-ever worldwide theatrical event for peace took place on Monday, March 3rd, 2003, with 1029 readings of Aristophanes' "Lysistrata" in 59 countries and in all 50 US states. The classic antiwar comedy tells the story of a group of women from warring Greek states who decide to withhold sex from their husbands until the men agree to lay down their swords. What the Lysistrata Project so beautifully displayed was both the organizing power of the Internet, and the passion with which the world opposed the war on Iraq. It was also extremely important to us that the rest of the world knows that not all Americans support the Bush Administration's policies, and we're very grateful to have communicated that message so clearly.

KATHRYN BLUME AND SHARRON BOWER CO-FOUNDERS, THE LYSISTRATA PROJECT

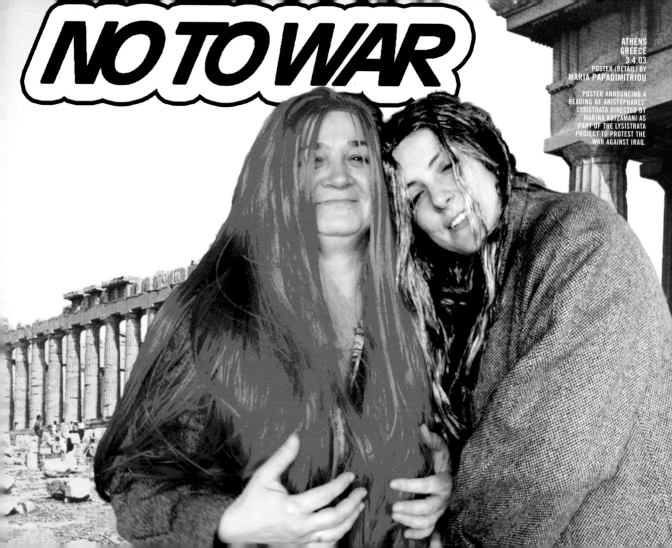

NO TO WAR

ATHENS
GREECE
3.4.03
POSTER (DETAIL) BY
MARIA PAPADIMITRIOU

POSTER ANNOUNCING A
READING OF ARISTOPHANES'
LYSISTRATA DIRECTED BY
MARINA KOTZAMANI AS
PART OF THE LYSISTRATA
PROJECT TO PROTEST THE
WAR AGAINST IRAQ.

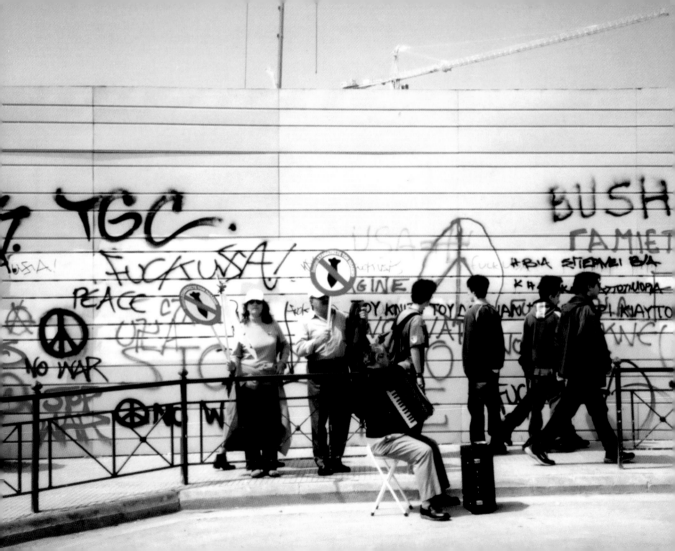

Austin

Dear Governor Bush, there is virtually NO ONE in America (talk radio nutters and Fox News aside) who is gung-ho to go to war. Trust me on this one. Walk out of the White House and on to any street in America and try to find five people who are PASSIONATE about wanting to kill Iraqis. YOU WON'T FIND THEM! Why? 'Cause NO Iraqis have ever come here and killed any of us! No Iraqi has even threatened to do that. You see, this is how we average Americans think: if a certain so-and-so is not perceived as a threat to our lives, then, believe it or not, we don't want to kill him! Funny how that works!

MICHAEL MOORE AUTHOR

WE DON'T WANT THIS WAR

AMERICAN FOR PEACE ☆ HELP STOP WAR ☆

AMERICAN FOR PEACE ☆ HELP STOP WAR ☆

AMERICAN FOR PEACE

AUSTIN
USA
2.15.03
PHOTO BY
BOB DAEMMRICH
THE IMAGE WORKS

ABOUT 12,000 ANTIWAR
MARCHERS RALLIED ON
SATURDAY AFTERNOON IN THE
TEXAS CAPITAL AS MILLIONS
GATHERED WORLDWIDE TO
PROTEST THE IMMINENT WAR
WITH IRAQ. IT WAS ONE OF THE
LARGEST POLITICAL DEMON-
STRATIONS IN TEXAN HISTORY.
DEMONSTRATORS OF ALL
AGES WORE COSTUMES AND
BANGED DRUMS, REMINISCENT
OF THE US ANTIWAR RALLIES
OF THE 1960s.

IMPEACH

AUSTIN
TEXAS
USA
3.20.03
PHOTO BY
MEL ROSENTHAL

UNIVERSITY OF TEXAS

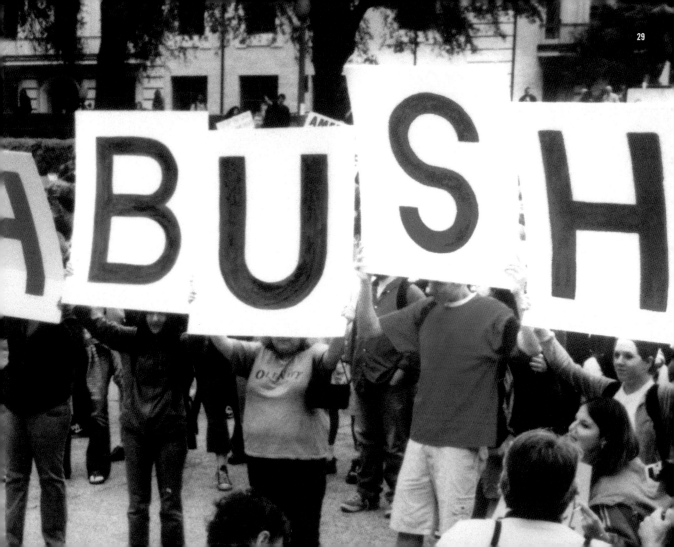

Baghdad

BAGHDAD
IRAQ
2.20.03
PHOTO BY
MARTIN SASSE
LAIF

SPIRITUAL LEADERS
GATHER IN FRONT OF
THE UNDP HEADQUARTERS
AT ABU NUWAS ON THE
BANK OF THE TIGRIS TO
PROTEST AGAINST WAR.

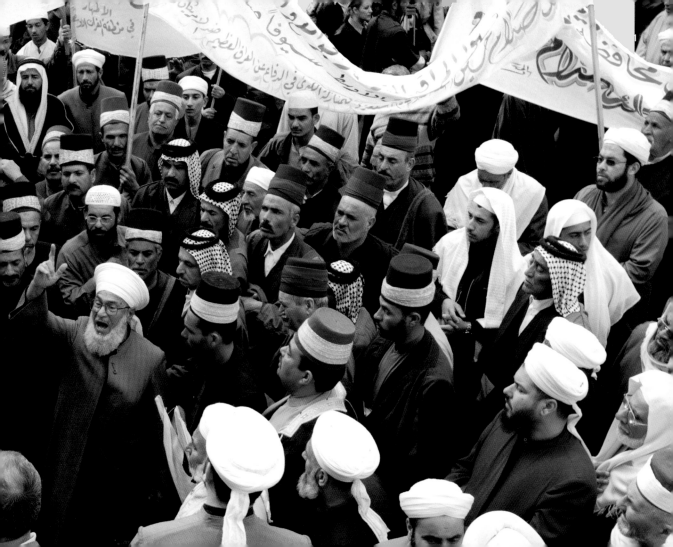

Speak out – for democracy in Iraq

Whatever America's real intentions behind an attack, the reality on the ground is that the majority of Iraqis, inside and outside Iraq, support invasive action, because they are the ones who have to live with the realities of continuing as things are – while people in the West wring their hands over the rights and wrongs of dropping bombs on Iraq, when in fact the US and the UK have been continuously dropping bombs on Iraq for the past twelve years.

I say to them: do not continue to allow the Iraqi people to be punished because you are 'unhappy' with the amount of power America is allowed to wield in a faulty world. Do not use the Iraqi people as a pawn in your game for moral superiority – when you allow a monster like Saddam to rule for thirty years without so much as protesting against his rule,

you lose the right to such a claim. I am not saying that war is a good thing and that all should happily support it, but I feel that the current antiwar movement has been hijacked by an anti-Americanism that ignores the horrors and realities of living under Saddam's rule.

If you want to make your disillusions heard then do speak out. March for democracy in Iraq, be part of ensuring that America doesn't just install another dictator after Saddam. There is much to admire about the movement; it has proven what people can achieve when they come together and speak out. Unfortunately for Iraq, nobody spoke out earlier.

RANIA KASHI YOUNG IRAQI CITIZEN: AN OPEN LETTER TO THE PEACE MOVEMENT 2.14.2003 WWW.OPENDEMOCRACY.NET

PEACE PEACE PEACE

BABYLON
IRAQ
2.21.03
PHOTO BY
MARTIN SASSE
LAIF

YOUNG CHILDREN HELD UP
PEACE SIGNS IN FRONT OF
THE RENOWNED ISHTAR
GATE OF BABYLON.

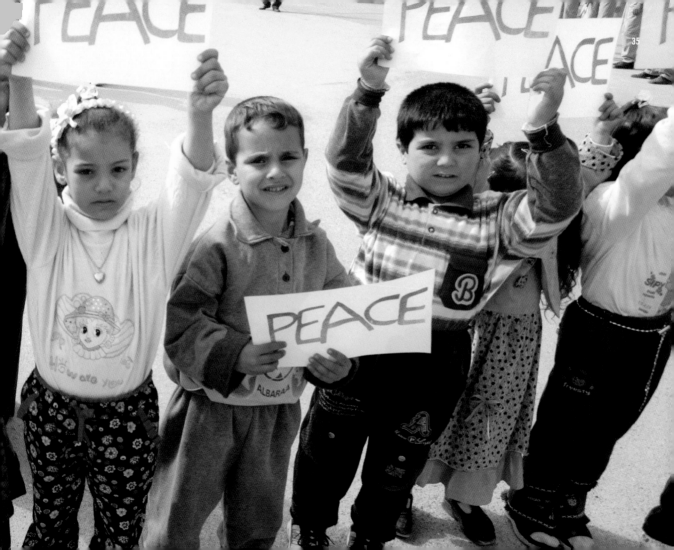

Barcelona

Polls indicated that over 80% of the citizens in Spain were radically opposed to the Iraq war. According to these polls and to the massive antiwar demonstrations throughout the country it seemed that President Aznar's blatant alignment with Bush and thus his disregard to listen to the will of his people would cost him dearly in the next elections.

The elections came and Aznar won. What happened?

Either war is not anymore an important enough issue to break or make politicians, or the citizens of the rich welfare societies might, after all, have the will to do but not the soul to dare.

ALBERTO FOYO ARCHITECT

BARCELONA
SPAIN
2.15.03
PHOTO BY
JUAN PEGORARO TERMINI

BARCELONA
SPAIN
2.15.03
PHOTOS BY
MARTIN RÜSTER

ON FEBRUARY 15TH,
BARCELONA SAW ITS
BIGGEST MANIFESTATION
IN HISTORY WITH AROUND
1.5 MILLION PEOPLE ON THE
STREETS AGAINST THE WAR
ON IRAQ. IT WAS A GOOD
FEELING TO BE PART OF IT.
WITH ANTIWAR BANNERS
PRACTICALLY EVERYWHERE
IN THE STREETS, FLYERS ON
THE WALLS AND GRAFFITI
ECHOING THE MANIFESTATION
MOTTOS I WANTED TO PUT A
FOCUS ONTO ALL THE SMALL
SIGNS, ARTWORK AND
GRAFFITI THAT WERE
PART OF 'SAYING NO'.

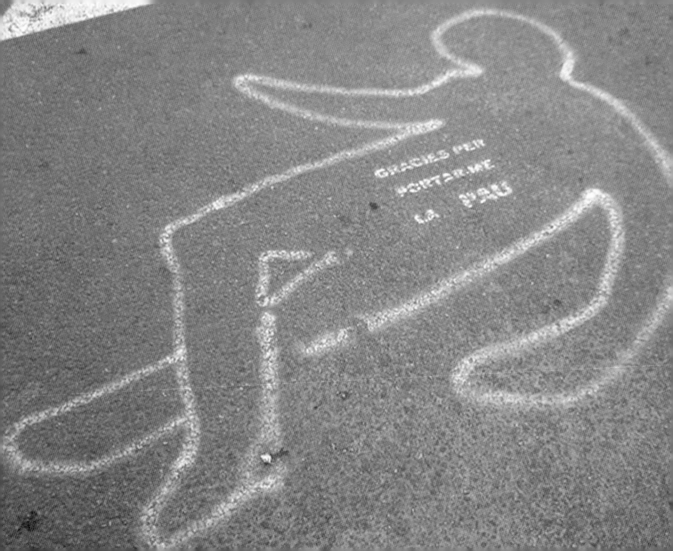

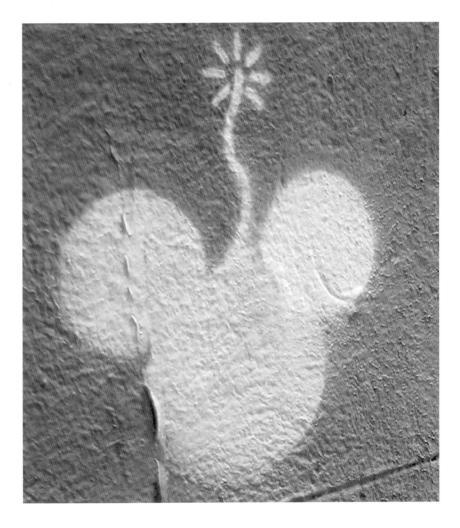

< >
BARCELONA
SPAIN
SPRING 03
PHOTOS BY
RUBEN VERDU

<
THANKS FOR
BRINGING
ME PEACE
>
MICKEY-BOMB

Berlin

Why of course the people don't want war.
But after all it is the leaders of the country who
determine the policy, and it is always a simple matter
to drag the people along, whether it is a democracy,
or a fascist dictatorship, or a parliament, or a
communist dictatorship. Voice or no voice, the
people can always be brought to the bidding of
the leaders. That is easy. All you have to do is to
tell them they are being attacked, and denounce
the pacifists for lack of patriotism and exposing
the country to danger.

HERMANN GOERING COMMANDER-IN-CHIEF OF THE LUFTWAFFE IN NAZI GERMANY AT THE NUREMBERG TRIALS

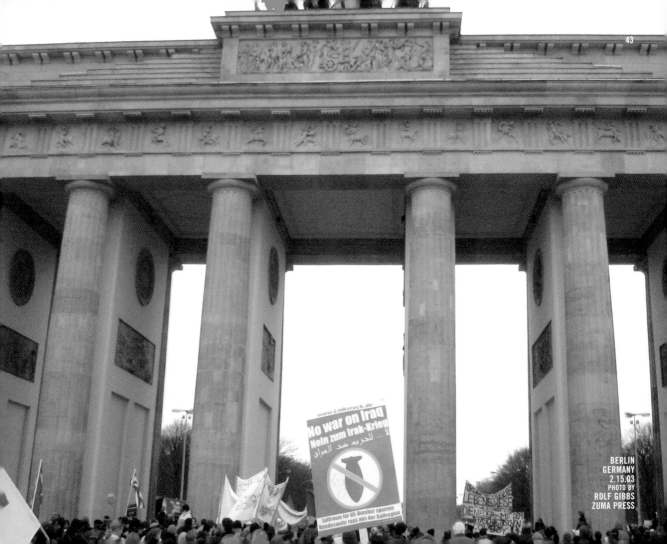

www.linksruck.de

No war on Iraq
Nein zum Irak-Krieg

لا ... للحرب ضد العراق

Luftraum für US-Bomber sperren
Bundeswehr raus aus der Golfregion

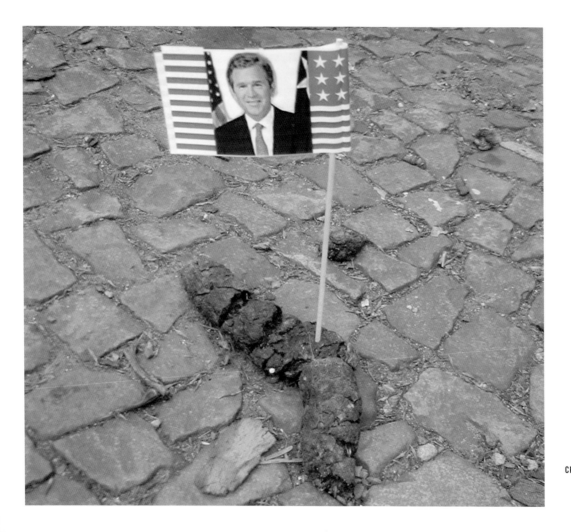

<
BERLIN
GERMANY
FEBRUARY 2003
PHOTO BY
CHRISTIANE GUDE

>
BERLIN
GERMANY
3.19.03
PHOTO BY
CHRISTIAN JUNGEBLODT

"NO WAR" PROJECTION
ONTO A BUILDING WALL
NEAR HACKESCHER MARKT

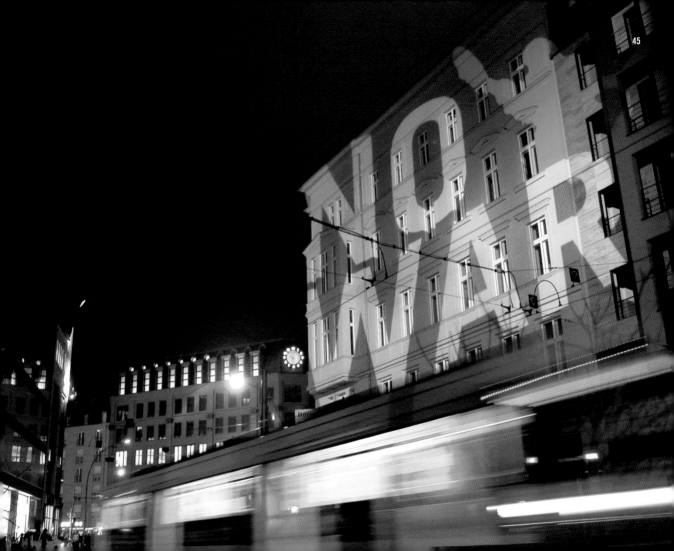

BERLIN
GERMANY
FEBRUARY 2003
PHOTO BY
CHRISTIANE GUDE

Peace is Pop

In pop, fashion, and youth culture
being for peace is an attitude
or a business, if not both.

TOBIAS HABERL JOURNALIST

A soccer fan demonstrating
against George Bush and
his political actions during
the game of Hertha BSC
vs. Boavista Porto.

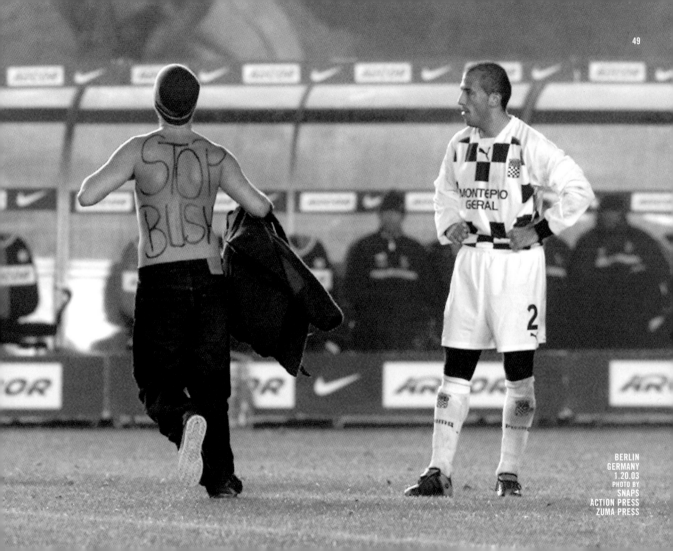

< >
BERLIN
GERMANY
FEBRUARY 2003
PHOTOS BY
CHRISTIANE GUDE

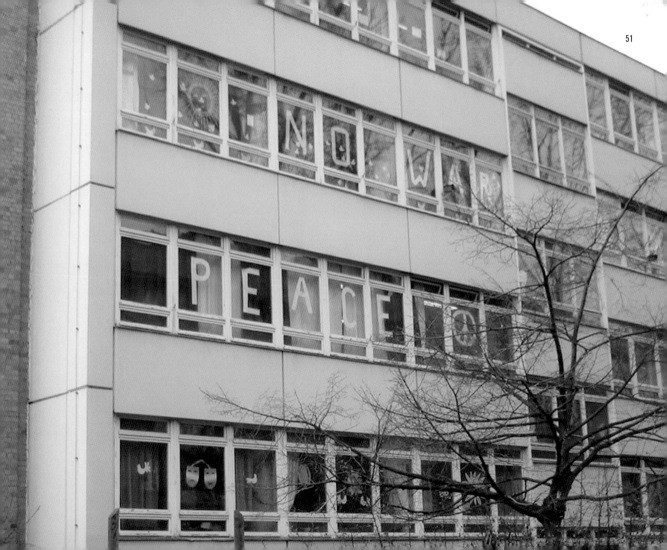

Are these the United States of America, the patient masters who taught the subject of democracy? Who forthrightly criticized themselves? The country which once was helped by the process of European enlightenment in overcoming colonial rule, gave itself an exemplary constitution and to whom the freedom of expression was an inalienable human right? Not only we are experiencing how this picture has faded and become a distortion of itself. There are also many Americans who love their country and are appalled at the decay of their innate values and at the hubris of their own power. I regard myself as allied with them. With them, I protest against the brutally executed injustice of the mightier and against any cynical calculation in which the death of many thousands of women and children is accepted when it comes to the preservation of economic and power interests.

GÜNTER GRASS AUTHOR

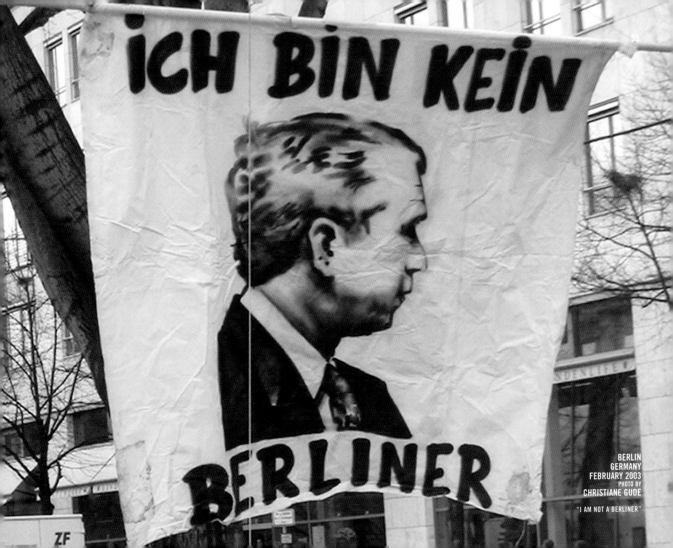

ICH BIN KEIN BERLINER

BERLIN
GERMANY
FEBRUARY 2003
PHOTO BY
CHRISTIANE GUDE

"I AM NOT A BERLINER"

Bern

We have assembled here today to speak a clear NO to war. The weight this cry for help can and will carry is not important. It is much more important to muster up the moral courage to say NO in a time of madness and political cynicism.
Not with us and not in our name! We are standing here in order to show that peace takes more courage than war, that people are more important than oil, that civil dis-obedience in times like ours is a duty and responsibility to history, to the present, and to the future.

VIOLA RAHEB THEOLOGIAN FROM BETHLEHEM, AT THE PEACE DEMONSTRATION IN BERN

BERN
SWITZERLAND
3.22.03
PHOTO BY
FRANZISKA
SCHEIDEGGER

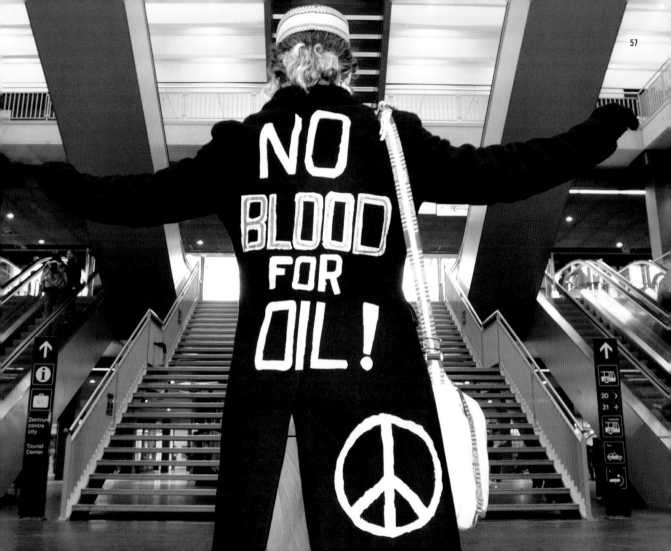

BERN
SWITZERLAND
2.15.03
PHOTO BY
ADRIAN MOSER

SWITZERLAND
ZURICH
MARCH 2003
POSTER BY
STEFANIE HERRMANN GERMANN
THOMAS GERMANN
GUIDO VORBURGER

A SERIES OF ANTIWAR POSTERS
WAS COMMISSIONED, PRINTED AND
DISTRIBUTED THROUGHOUT SWITZERLAND
BY PLAKATE GEGEN DEN KRIEG
HTTP://PLAKATE.NETZWIRT.CH

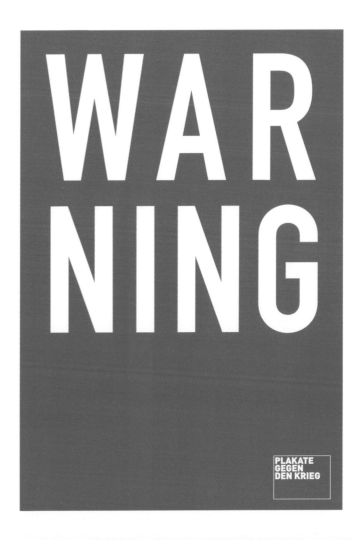

Bombay

There's no peace movement
in India because peace
is a daily battle for dignity
for most people here.

ARUNDHATI ROY AUTHOR

BOMBAY
INDIA
3.7.03
PHOTO BY
FAWZAN HUSAIN
PHOTOINK

Brussels

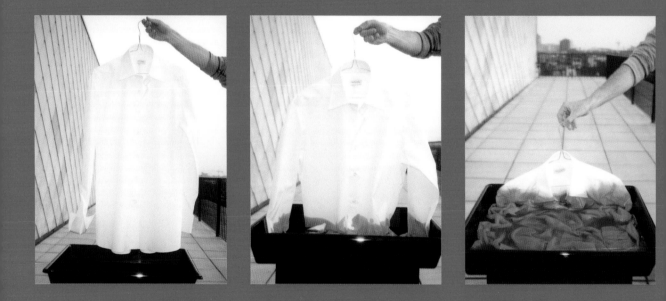

DRIES VAN NOTEN FASHION DESIGNER, CREATED FOR I-D MAGAZINE'S ACTION ISSUE, JUNE 2003

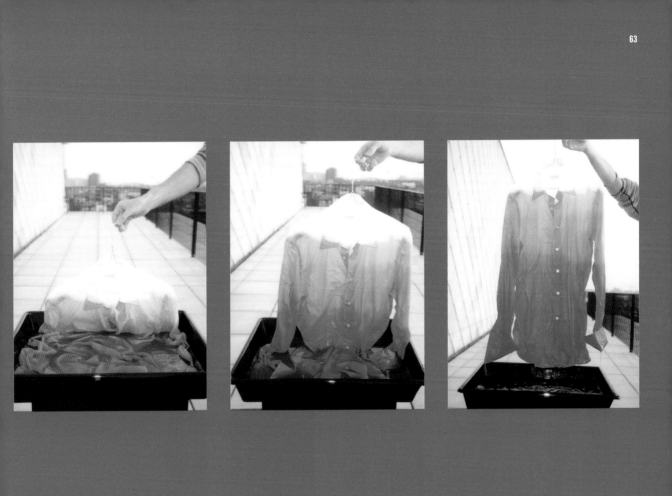

Buenos Aires

BUENOS AIRES
ARGENTINA
4.6.03
PHOTO BY
MARCELO BRODSKY

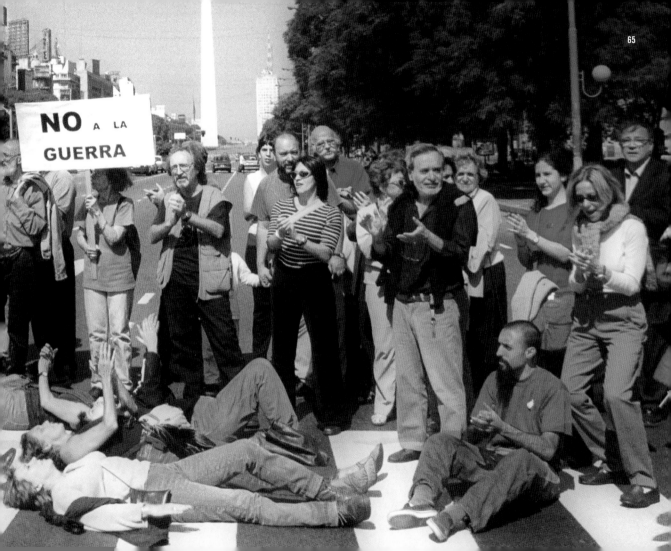

Cape Town

War would be devastating not just to Iraq
but also to the whole of the Middle East
and to other countries of the world.
In a situation like that, we would have
to say goodbye to African development.

THABO MBEKI PRESIDENT OF SOUTH AFRICA

REVOLUTIONARY
SOCIALIST
GREED
+ OIL
= WAR
Phantsi Bush, Blair
& neo-liberalism

INTERNATIONAL
SOCIALIST

CAPE TOWN
SOUTH AFRICA
2.15.03
PHOTO BY
ERIC MILLER

SOME OF THE THOUSANDS OF
CAPETONIANS WHO MARCHED
THROUGH THE CITY STREETS IN
PROTEST AGAINST THE BUILD
UP TO WAR BY THE US/UK
COALITION AGAINST IRAQ.
THE DEMONSTRATORS
GATHERED PEACEFULLY
AROUND THE HEAVILY
PROTECTED US CONSULATE IN
THE CITY BEFORE DISPERSING.

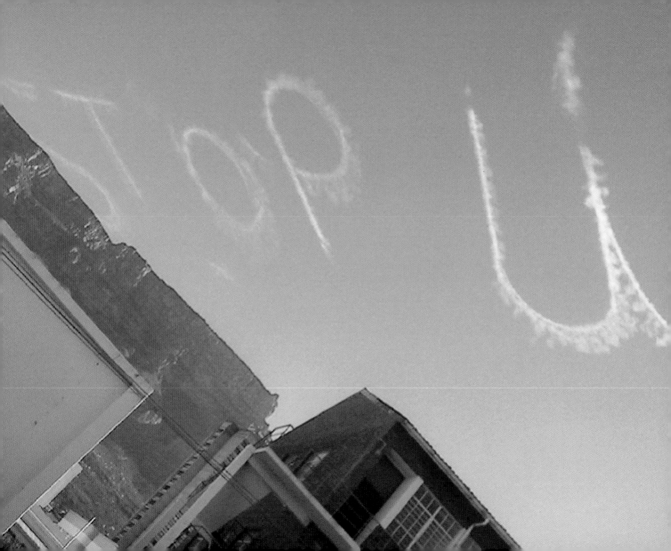

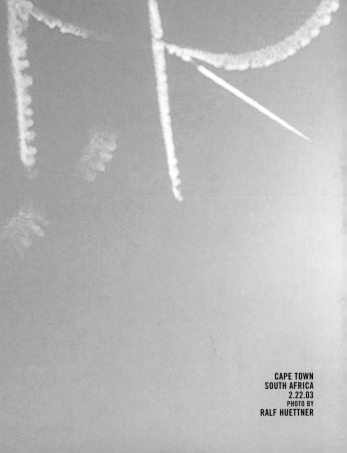

CAPE TOWN
SOUTH AFRICA
2.22.03
PHOTO BY
RALF HUETTNER

Copenhagen

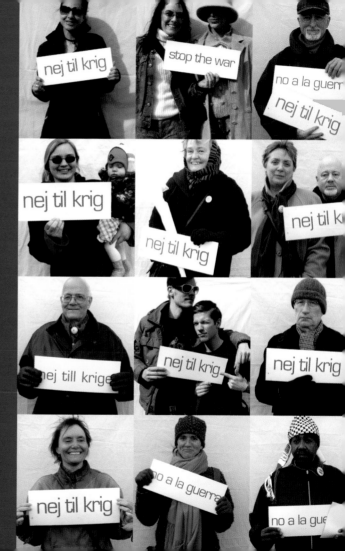

**COPENHAGEN
DENMARK
MARCH-APRIL 2003
PHOTOS BY
ROLANDO DIAZ**

INDIVIDUALS AT DANISH PEACE
DEMONSTRATIONS WERE
PHOTOGRAPHED STANDING
WITH "STOP THE WAR" SIGNS.
HUNDREDS OF PORTRAITS
WERE EXHIBITED ON POSTERS
AND COLLECTED AT
WWW.STANDFORPEACE.DK
AS AN ONGOING SHOW OF
SUPPORT FOR NON-VIOLENCE.
THIS PROJECT WAS ORGANIZED
BY ROLANDO DIAZ AND
NANCY MUNFORD.

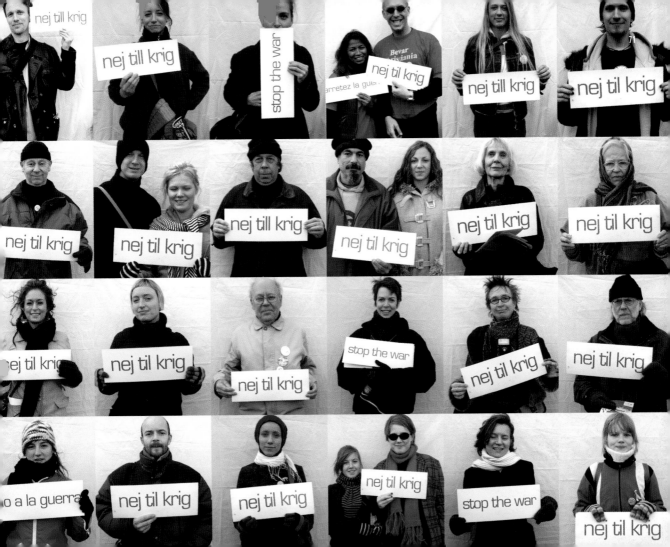

Detroit

NOUR CAB.

6289

NO

DETROIT
USA
2.15.03
PHOTO BY
RENEÉ LANDUYT

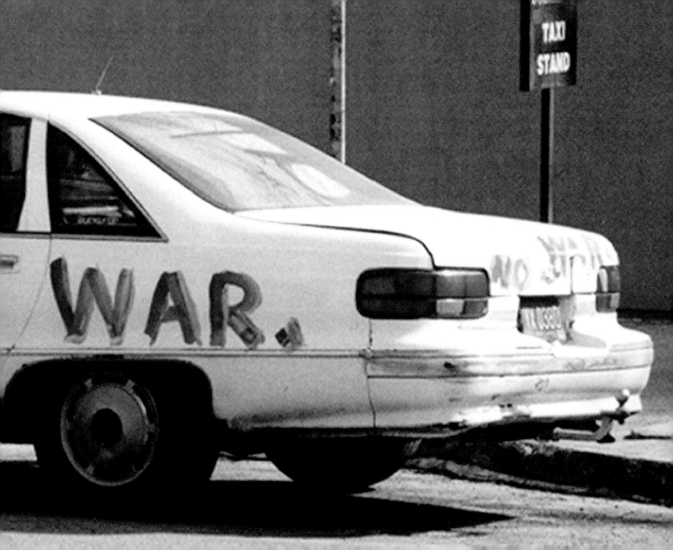

Public demonstrations are as American as apple pie and very democratic. America's origins began with protests, if you go back to the Boston Tea Party. This is a form of politics in which everyone can participate. You don't have to be 18 or a US citizen. You just have to turn out on a given day and join your neighbors.

LOUIS DE SIPIO PROFESSOR OF POLITICAL SCIENCE, UNIVERSITY OF CALIFORNIA/IRVINE

75

DETROIT
USA
3.18.03
PHOTO BY
JIM WEST
THE IMAGE WORKS

SEVERAL HUNDRED PEOPLE
FROM VARIOUS RELIGIOUS
GROUPS MARCHED FROM
CENTRAL UNITED METHODIST
CHURCH TO THE FEDERAL
COURTHOUSE, WHERE THEY
READ AN INDICTMENT
CHARGING THE BUSH
ADMINISTRATION WITH
'CRIMES AGAINST PEACE'.
THEN THEY BLOCKED
ENTRANCES TO THE COURT-
HOUSE IN A PROTEST AGAINST
WAR WITH IRAQ. TWENTY-
SEVEN WERE ARRESTED.

Dhaka

Today's real borders are not between nations,
but between powerful and powerless,
free and fettered, privileged and humiliated.
Today, no walls can separate humanitarian
or human rights crises in one part of the world
from national security crises in another.

KOFI ANNAN UN SECRETARY-GENERAL IN HIS ACCEPTANCE SPEECH FOR THE NOBEL PEACE PRIZE, OSLO, 12.10.01 © THE NOBEL FOUNDATION

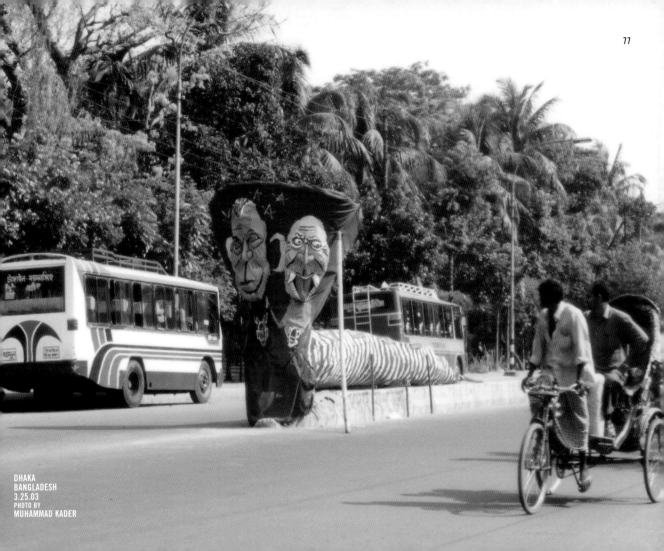

DHAKA
BANGLADESH
3.25.03
PHOTO BY
MUHAMMAD KADER

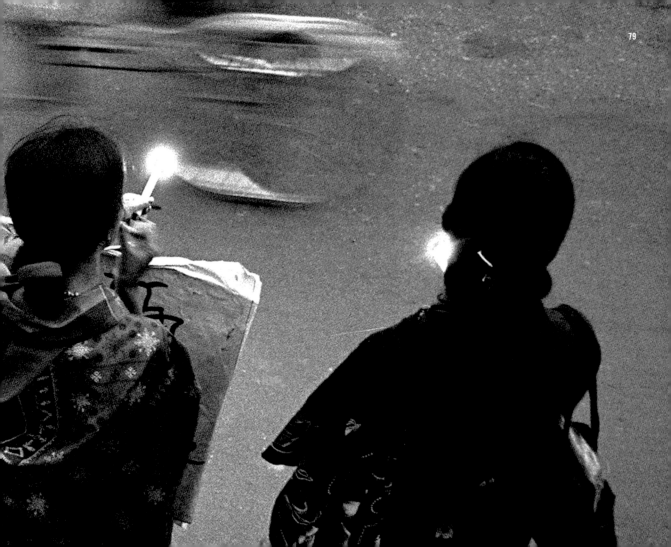

Glasgow

I am supposed to feel alone. I am supposed to be stupid, selfish, and afraid. I am supposed to consume and to generate personal debt. I am supposed to have no soul, no interior privacy, no right to question, or to speak. I am supposed to be powerless.
But at the marches, the sit-ins, the vigils, in chance conversations with strangers on the street – that's when other human beings remind me that this is a lie: all a greedy, degrading and blasphemous lie.
That's when I remember the truth of myself.

A.L. KENNEDY AUTHOR

WE ARE ALL FRENCH NOW.

GLASGOW
SCOTLAND
2.15.03
PHOTO BY
ALAN WILSON

Gothenburg

War is always a failure. A war outside the United
Nations charter is a great failure. We all fear new
terrorist acts. International terrorism is a threat
to our societies and our security.
But the fight against terrorism must never be
allowed to justify violations of human rights.
International humanitarian law and human rights have
to be respected at all times, also in time of crisis.

ANNA LINDH SWEDISH FOREIGN MINISTER

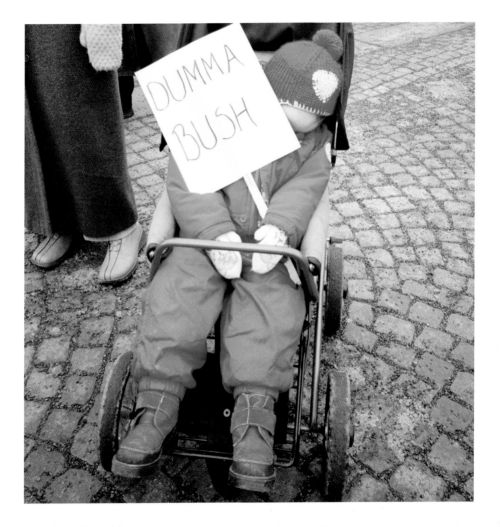

GOTHENBURG
SWEDEN
2.15.03
PHOTO BY
SVANTE ÖRNBERG

"STUPID BUSH"

Iskenderun

Everyone's national sensibilities were hurt by the coverage of Turkey in the Western media as a country that would engage in a war it did not believe in for the sake of American dollars.
Like the leaders of many other countries, the Turkish prime minister is trapped between the pressures of the Bush government and the indignation of the people. With a debt burden of 80 billion dollars to international western lenders, Turkey could be plunged overnight into an economic crisis similar to that of Argentina if deprived of IMF support.

ORHAN PAMUK AUTHOR

ISKERDERUN
TURKEY
3.15.03
PHOTO BY
AMI VITALE

ANTI-WAR PROTESTERS WAVING
FLAGS AT A RALLY IN THE PORT
CITY OF ISKENDERUN, TURKEY.
WASHINGTON WAS PRESSING
TURKEY TO AUTHORIZE THE
STATIONING OF 62,000 US
COMBAT TROOPS TO OPEN
A NORTHERN FRONT.
THE TURKISH PUBLIC WAS
OVERWHELMINGLY OPPOSED
TO THE WAR AND LAWMAKERS
WERE UNEASY ABOUT THE
IDEA OF LETTING IN TENS OF
THOUSANDS OF US TROOPS.

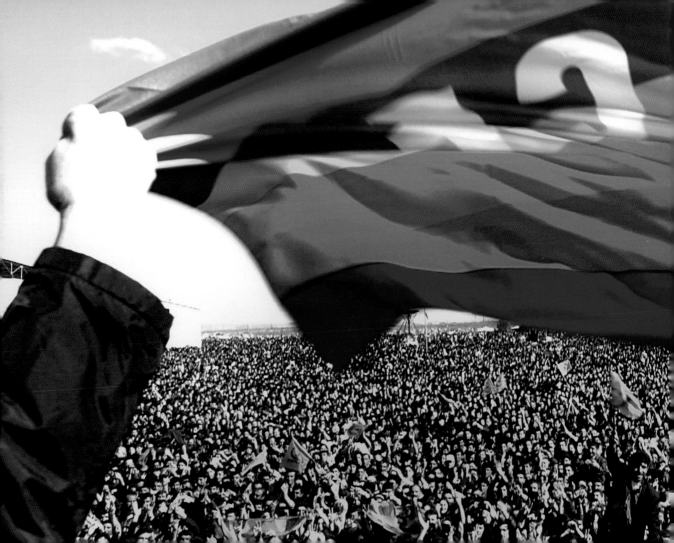

DIYARKABIR
TURKEY
3.21.03
PHOTO BY
AMY VITALE

KURDS WAVING A PEACE FLAG
TO CELEBRATE THE NEWROZ
FESTIVAL TO MARK THE FIRST
DAY OF SPRING, IN THE
SUBURBS OF DIYARKABIR,
SOUTHEASTERN TURKEY.

Karachi

People are relying on Al-Jazeera because they think it's giving the other side of the picture. Western coverage of the war is considered a bit biased.

BABAR AYAZ DIRECTOR OF THE MEDIA CONSULTANCY MEDIATOR GROUP IN: PAKISTAN'S CABLE TV CHANNELS ENTER WAR FOR AIRWAVES [LISTS.ISB.SDNPK.ORG]

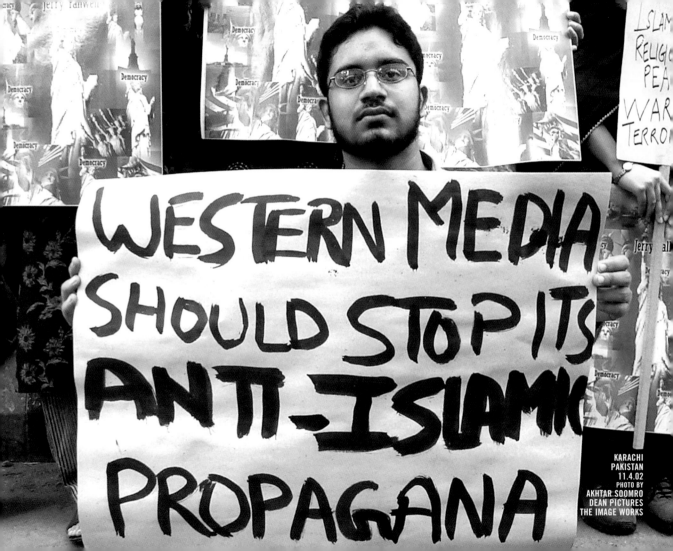

WESTERN MEDIA SHOULD STOP ITS ANTI-ISLAMIC PROPAGANA

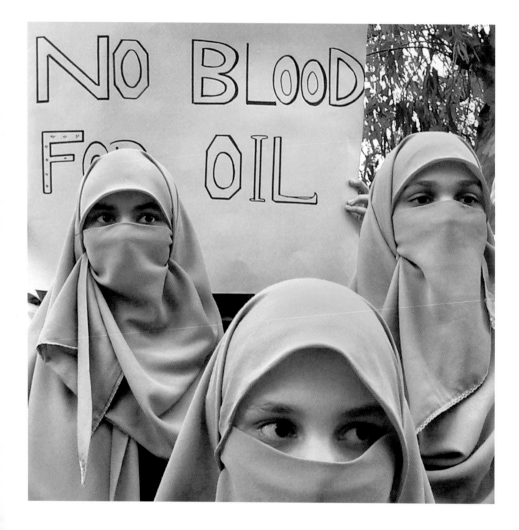

< >
KARACHI
PAKISTAN
<2.26.03
>2.28.03
PHOTOS BY
AKHTAR SOOMRO
DEANPICTURES
THE IMAGE WORKS

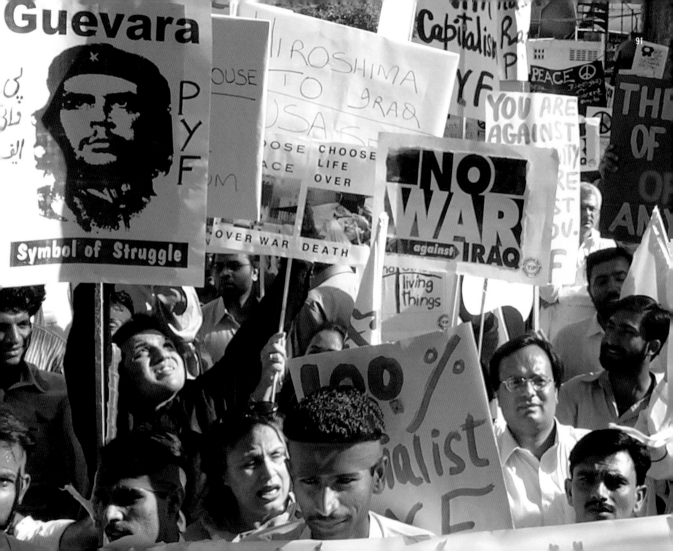

London

We've never really seen a movement like this before – it's unpredictable because it's so unprecedented. But it does seem that a large proportion of the people who participated [on February 15th] are becoming quite politicized just by going to the demonstration.

PAUL ROGERS PROFESSOR OF PEACE STUDIES AT BRADFORD UNIVERSITY

LONDON
ENGLAND
2.15.03
PHOTO BY
JESS HURD
REPORT DIGITAL

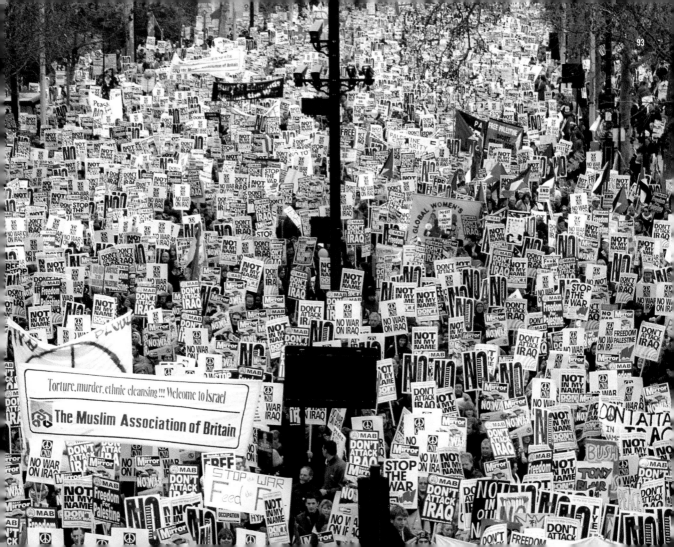

Torture, murder, ethnic cleansing !!! Welcome to Israel

The Muslim Association of Britain

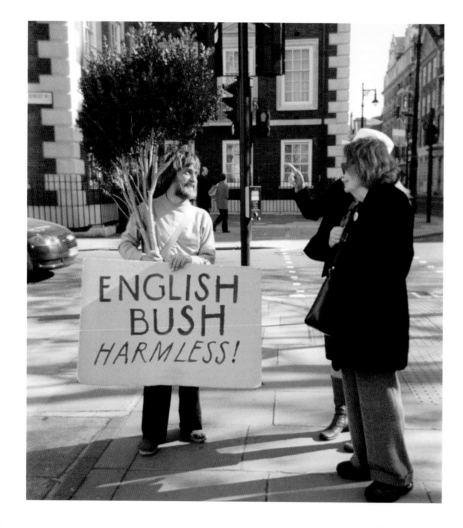

ENGLISH
BUSH
HARMLESS!

<
LONDON
ENGLAND
3.5.03
PHOTO BY
A.L. KENNEDY

ENGLISH BUSH SIGHTED
NEAR THE US EMBASSY.

>
LONDON
ENGLAND
2.15.03
PHOTO BY
MICHALIS SOURLIS
NBPICTURES

THE PAINTED FACE OF A
PROTESTOR DURING THE PEACE
MARCH THROUGH LONDON.
OVER A MILLION PEOPLE
JOINED THE MARCH MAKING IT
THE BIGGEST IN UK HISTORY.

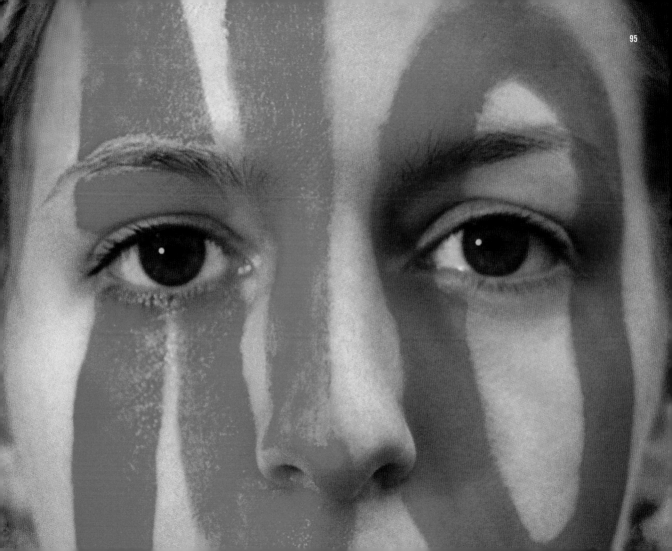

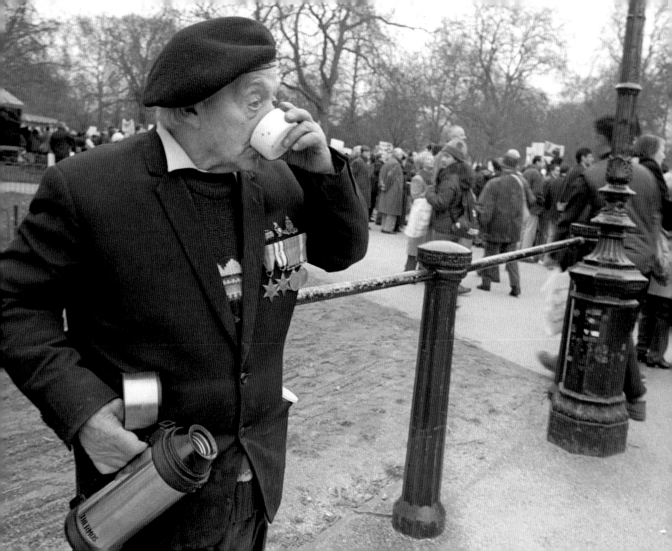

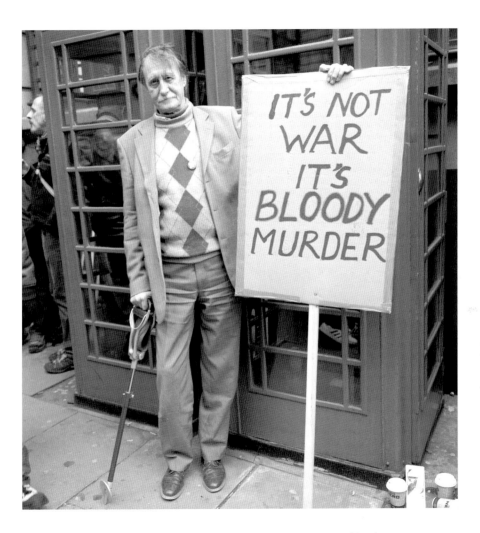

Here we are, a kind of Ground Zero
for the total disconnection between
the citizens' wishes and what is done
in our name by politicians.

OLIVER JAMES CLINICAL PSYCHOLOGIST AND AUTHOR

LONDON
ENGLAND
3.20.03
PHOTO BY
JESS HURD
REPORT DIGITAL

STUDENTS STRIKE
AGAINST 1ST DAY
OF WAR WITH IRAQ.

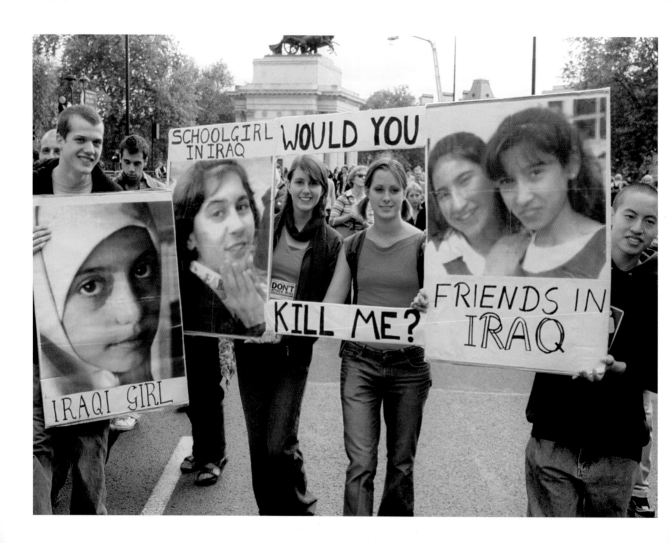

STOP THE WAR BLAIR MUST GO

Los Angeles

Actors have been speaking up,
but there's been a dismaying
backlash against them.
For many mainstream Americans,
actors' celebrity is a reason why
they should not speak.
Their politics look like a pose, a
fashion statement or publicity stunt.
But actors are citizens too.

CAMILLE PAGLIA AUTHOR

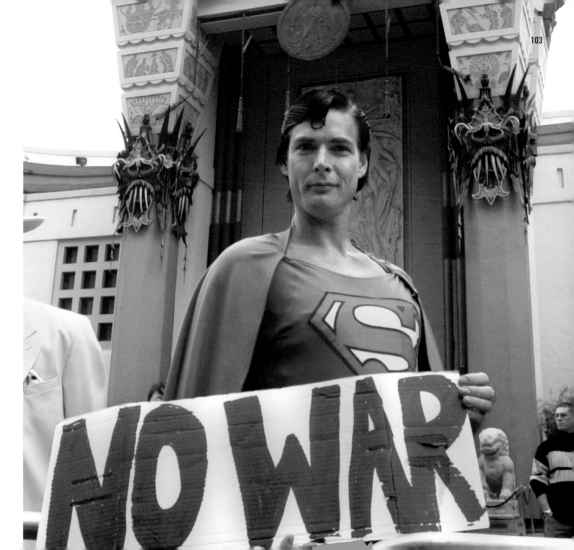

LOS ANGELES
USA
2.15.03
PHOTO BY
BRANIMIR KVARTUC
ZUMA PRESS

ACTOR CHRISTOPHER DENNIS
IN A SUPERMAN COSTUME
PARTICIPATES IN THE ANTI
WAR PROTEST IN HOLLYWOOD
AS THE MARCH PASSES BY
MANN'S CHINESE THEATER.

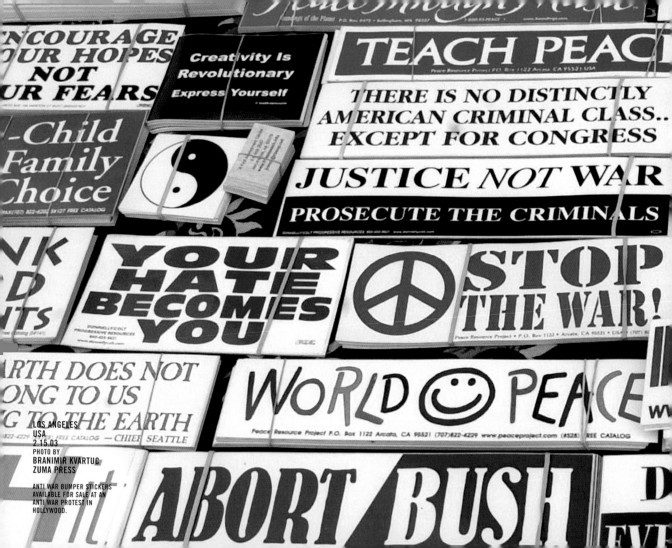

NCOURAGE
UR HOPES
NOT
UR FEARS

-Child
Family
Choice

Creativity Is
Revolutionary
Express Yourself

TEACH PEACE

THERE IS NO DISTINCTLY
AMERICAN CRIMINAL CLASS...
EXCEPT FOR CONGRESS

JUSTICE NOT WAR

PROSECUTE THE CRIMINALS

YOUR
HATE
BECOMES
YOU

STOP
THE WAR!

RTH DOES NOT
ONG TO US
G TO THE EARTH
— CHIEF SEATTLE

WORLD ☺ PEACE

Peace Resource Project P.O. Box 1122 Arcata, CA 95521 (707)822-4229 www.peaceproject.com (#528) FREE CATALOG

ABORT/BUSH

LOS ANGELES
USA
2.15.03
PHOTO BY
BRANIMIR KVARTUC
ZUMA PRESS

ANTI WAR BUMPER STICKERS
AVAILABLE FOR SALE AT AN
ANTI WAR PROTEST IN
HOLLYWOOD.

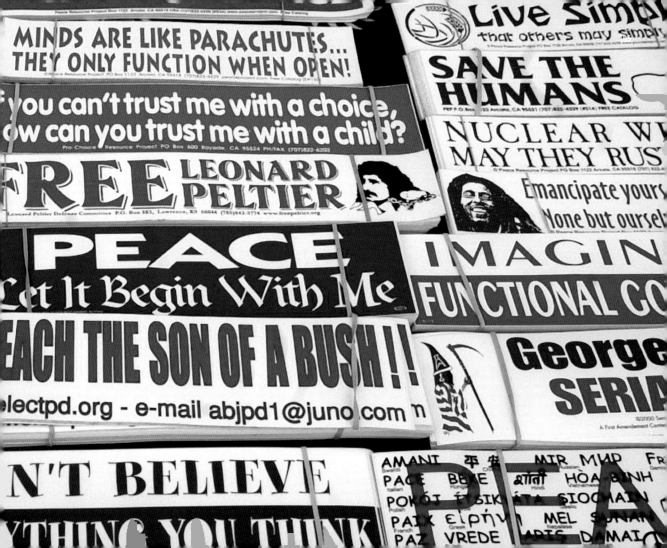

Madrid

They believed we had become tired of protests and we had left them free to continue in their deluded race towards war. They were mistaken. Today, those of us demonstrating, here and all over the world, are that horsefly that comes back again and again, relentlessly, to sting on the vulnerable parts of the beast. They want war, but we are not going to leave them in peace. Without peace, without an authentic peace, fair and respectful, there won't be human rights. And without human rights (all of them, one by one) democracy won't be anything else but a sarcasm, an offense to reason, a mockery.

JOSÉ SARAMAGO AUTHOR AT THE DEMONSTRATION IN MADRID ON 3-15-03 [REBELION.ORG]

NO A LA GUERRA

NO A LA GUERRA

MADRID
SPAIN
2.15.03
PHOTO BY
JOSÉ ANTONIO ROJO

ANTIWAR PERFORMANCE
AT ARCO, INTERNATIONAL
FAIR OF MODERN ART

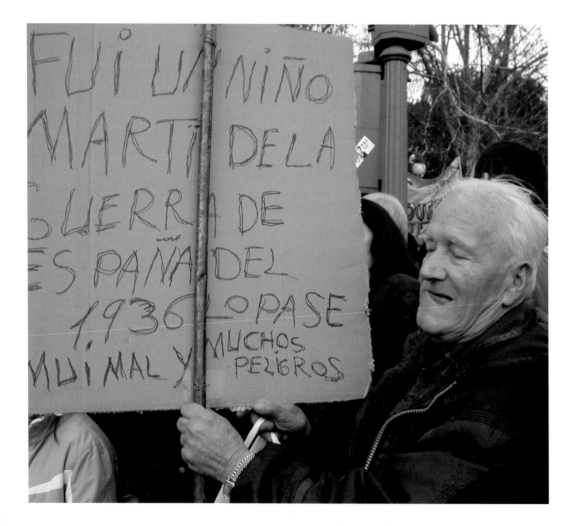

FUI UN NIÑO
MARTI DE LA
GUERRA DE
ESPAÑA DEL
1936 LO PASE
MUI MAL Y MUCHOS
PELIGROS

A very old demonstrator, who lived through the Spanish Civil War in 1936 carried a banner saying: "I was a martyr kid in the Spanish war in 1936 and suffered greatly and endured many dangers." What moved me most was the effort it took the old man to write this message, filled with misspellings and grammatical errors, probably because he had to miss school during the civil war and the years after, and yet, the fierce courage he felt to walk out into the streets and make his voice heard.

ALEJANDRO CHEREP PHOTOGRAPHER

Milan

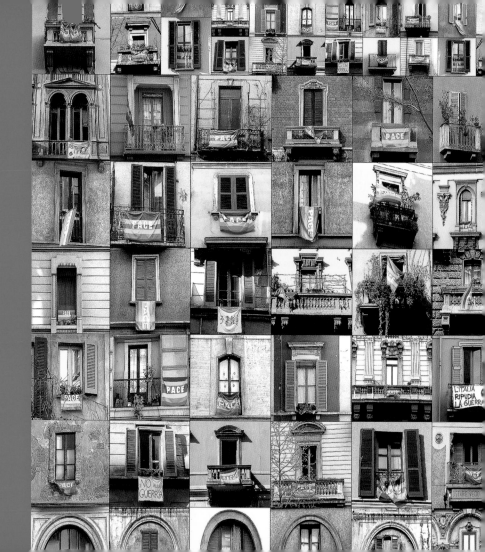

**MILAN
ITALY
MARCH 2003
PHOTO BY
MAURO COLELLA**

THIS COLLAGE WAS PART OF
THE EXHIBIT 'IMAGES AGAINST
WAR' WITH AN ONLINE GALLERY
AT 'IMAGESAGAINSTWAR.COM'.
THE EXHIBIT WAS ORGANIZED
BY TINA SCHELLHORN,
GALERIE LICHTBLICK, COLOGNE

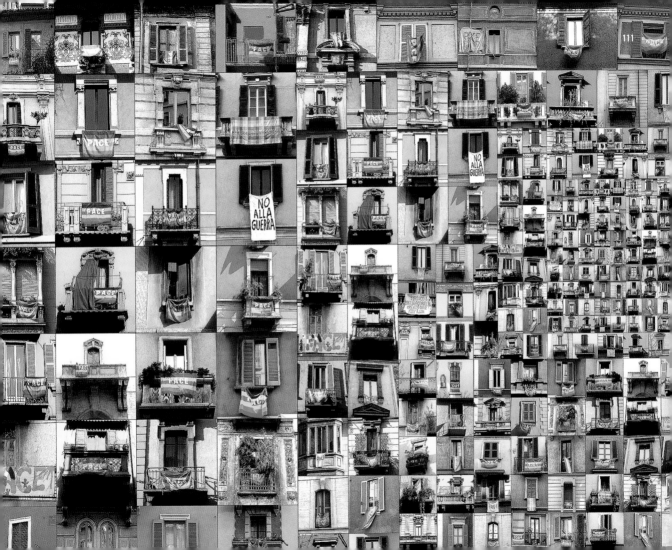

MILAN
ITALY
3.20.03
PHOTO BY
ALESSANDRO TOSATTO
CONTRASTO

PEACE DEMONSTRATION TO
PROTEST AGAINST THE PENDING
WAR THE NIGHT BEFORE ALLIED
TROOPS STARTED TO BOMB
IRAQ — A CROWD OF DEMON-
STRATORS HOLDING UP A HUGE
RAINBOW PEACE BANNER.

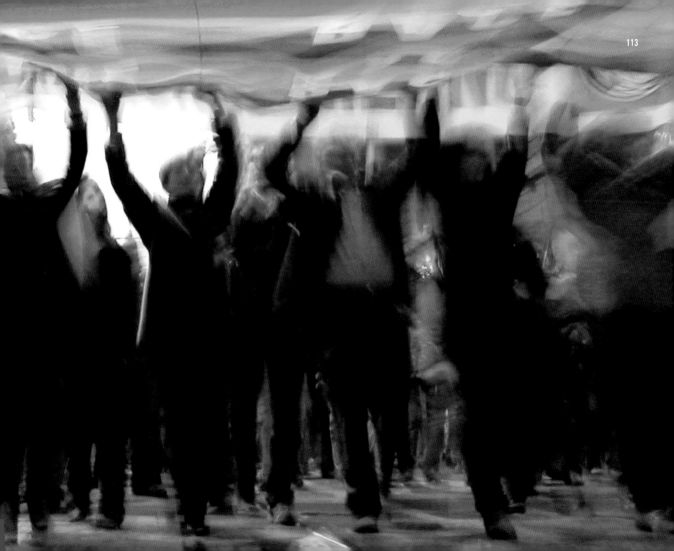

Moscow

In all history there is no war
which was not hatched by the
governments, the governments alone,
independent of the interests of the
people, to whom war is always
pernicious even when successful.

LEO TOLSTOY AUTHOR

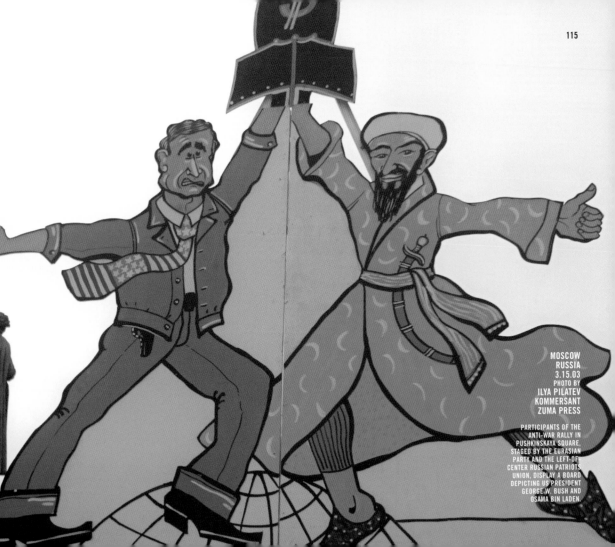

MOSCOW
RUSSIA
3.15.03
PHOTO BY
ILYA PILATEV
KOMMERSANT
ZUMA PRESS

PARTICIPANTS OF THE
ANTI-WAR RALLY IN
PUSHKINSKAYA SQUARE,
STAGED BY THE EURASIAN
PARTY AND THE LEFT-OF-
CENTER RUSSIAN PATRIOTS
UNION, DISPLAY A BOARD
DEPICTING US PRESIDENT
GEORGE W. BUSH AND
OSAMA BIN LADEN.

New York

We have created the largest, most broadly based peace movement in history — a movement that has engaged millions of people here and around the globe. Antiwar rallies and vigils have occurred in thousands of communities, and many cities have passed antiwar declarations.
The fact that this effort could not prevent war reflects not the weaknesses of our movement but the failures of American democracy and the entrenched power of US militarism.

DAVID CORTRIGHT AUTHOR AND POLITICAL SCIENTIST

NEW YORK
USA
2.15.03
PHOTO BY
MONIKA GRAFF
THE IMAGE WORKS

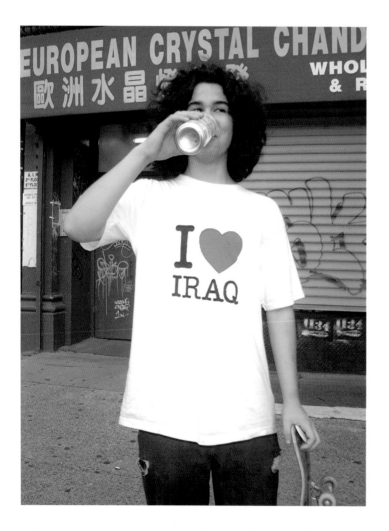

NEW YORK
USA
SPRING 03
PHOTO BY
DAMIEN TOTMAN

On Feb. 15th a movement came to life as millions of people in over 900 cities in every continent said no to war in one clear voice. In NYC the police and mayor and courts and the U.S. Dept. of Justice all tried to stop us, but the determination of 500,000 people to be heard was stronger than any obstacle they threw our way.

We were not able to stop the US war against Iraq, but a new force for peace and justice throughout the country and around the world has been generated. Feb. 15th will be remembered as the kick-off of a movement strong enough to stop outrageous wars and creative enough to bring lasting change.

LESLIE CAGAN COORDINATOR, UNITED FOR PEACE AND JUSTICE AND ORGANIZER OF THE NYC FEB. 15TH DEMONSTRATION

NEW YORK
USA
9.11.02
PHOTO BY
ALICE ARNOLD

DIE-IN, UNION SQUARE

NEW YORK
USA
3.22.03
PHOTO BY
JOSEPHINE MECKSEPER

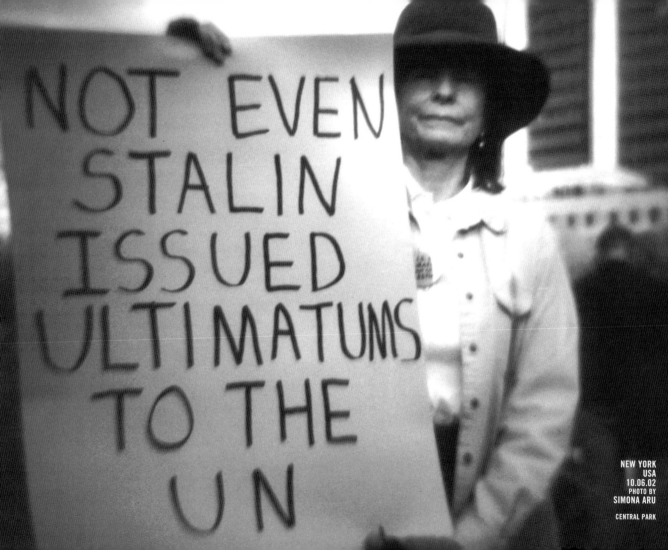

NOT EVEN STALIN ISSUED ULTIMATUMS TO THE UN

NEW YORK
USA
10.06.02
PHOTO BY
SIMONA ARU

CENTRAL PARK

There is a power which can serve as a check against abuses by a government or by government officials and that power is the power of the informed citizen — one who has read enough, who understands enough, who has developed a base of knowledge against which to judge truth or falsehood.
Participation in the great debates of our time must not be relegated to the power elites in Washington. An informed citizenry has to participate, ask questions, and demand answers and accountability to make a country like ours work.

ROBERT BYRD SENATOR FROM WEST VIRGINIA

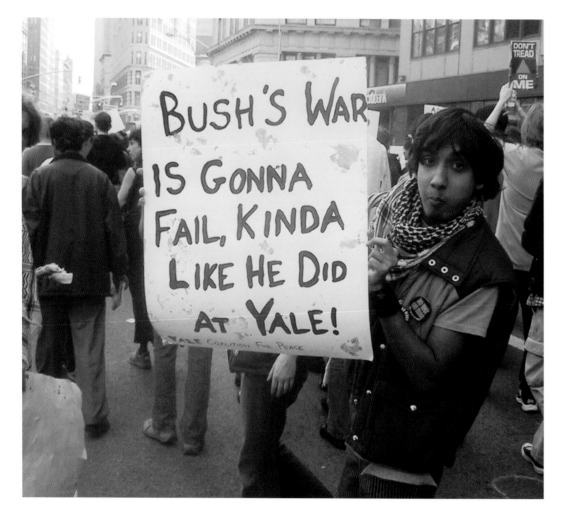

<
NEW YORK
USA
3.22.03
PHOTO BY
BARRY HOGGARD

YALE STUDENTS,
BROADWAY AT 25TH STREET

>
NEW YORK
USA
3.22.03
PHOTO BY
BOB STEIN

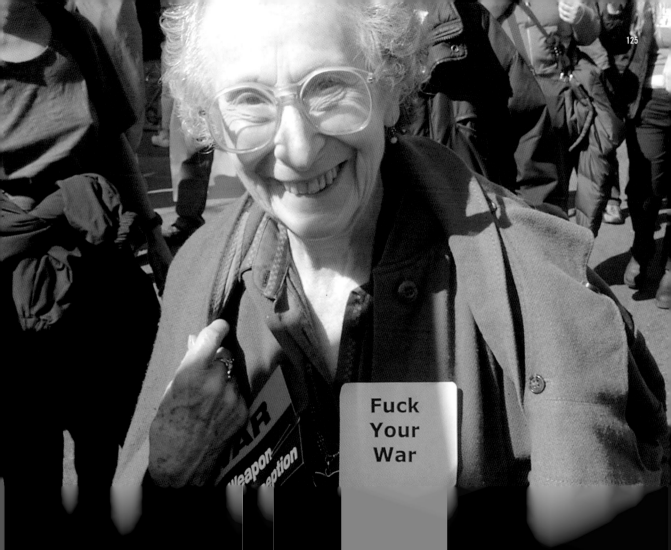

Fuck
Your
War

NEW YORK
USA
2.15.03
PHOTO BY
YOLANTA ZAWADA

**What happened on February 15th
was emblematic of a city
where the visceral response
to political protest is
to contain it and curtail it.**

DONNA LIEBERMAN EXECUTIVE DIRECTOR OF THE NEW YORK CIVIL LIBERTIES UNION

We prepare for our extinction
in order to insure our survival.
If our species does destroy itself,
it will be a death in the cradle —
a case of infant mortality.

JONATHAN SCHELL AUTHOR

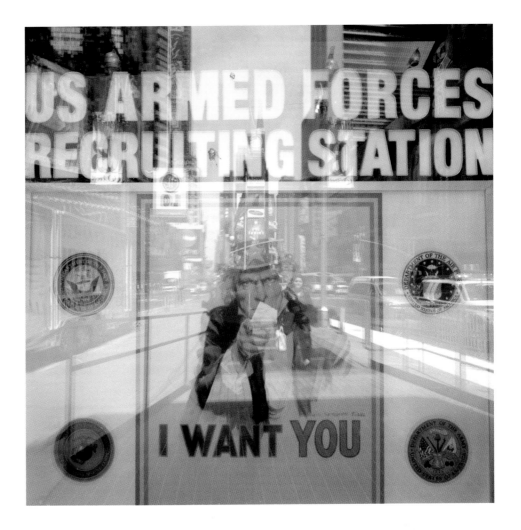

NEW YORK
USA
FEBRUARY 2003
PHOTO BY
CHRISTIAN LUTZ

I'm so honored to be alive at such a miraculous time in history. I'm so moved by what's going on in our world today. Never before in the history of the world has there been a global, visible, public, viable, open dialogue and conversation about the very legitimacy of war. Shock and awe has found its riposte in courage and wonder.

DR. ROBERT MULLER FORMER ASSISTANT SECRETARY-GENERAL OF THE UNITED NATIONS

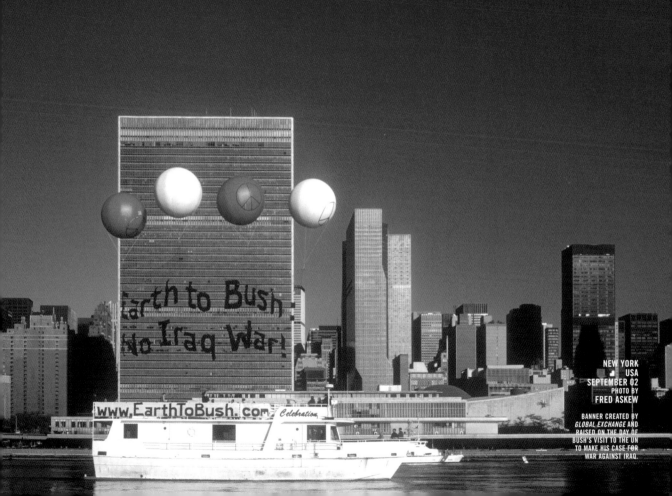

131

NEW YORK
USA
SEPTEMBER 02
PHOTO BY
FRED ASKEW

BANNER CREATED BY
GLOBAL EXCHANGE AND
RAISED ON THE DAY OF
BUSH'S VISIT TO THE UN
TO MAKE HIS CASE FOR
WAR AGAINST IRAQ.

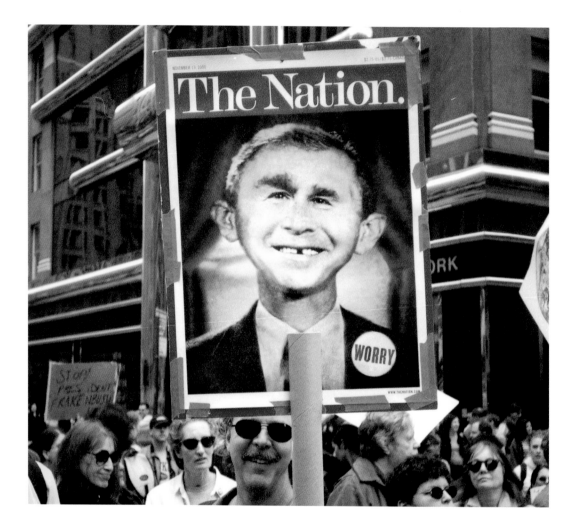

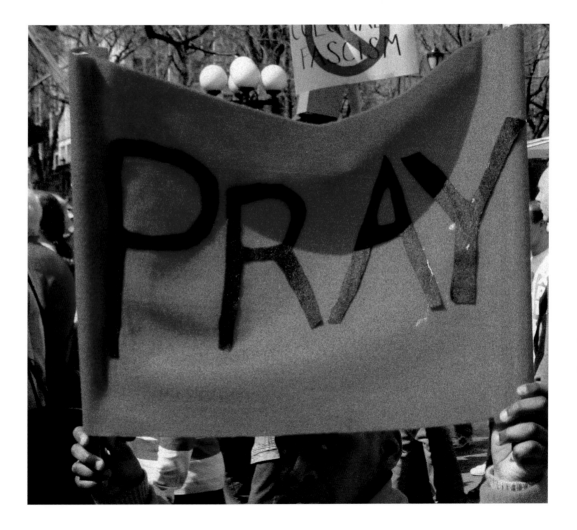

<
NEW YORK
USA
3.22.03
PHOTO BY
KLAUS SCHOENWIESE

>
NEW YORK
USA
3.22.03
PHOTO BY
JENNIFER COLLINS

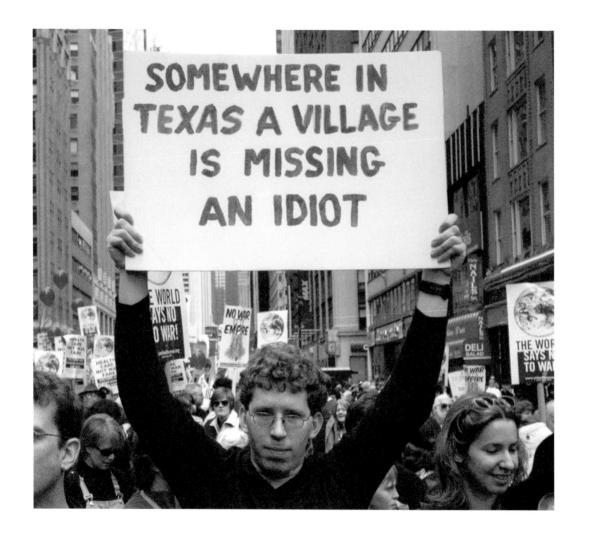

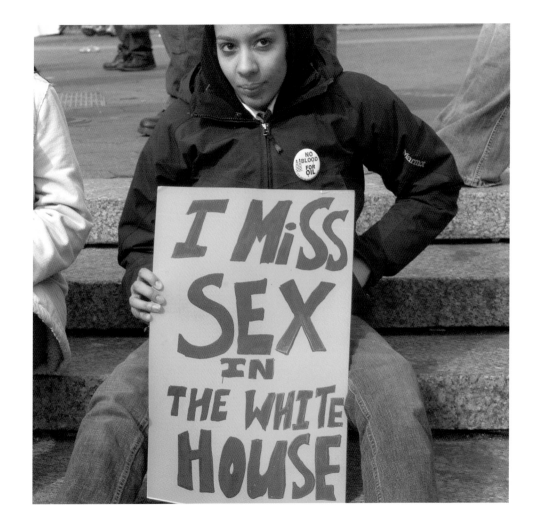

<
NEW YORK
USA
3.22.03
PHOTO BY
KLAUS SCHOENWIESE

>
NEW YORK
USA
3.19.03
PHOTO BY
STEFAN FALKE

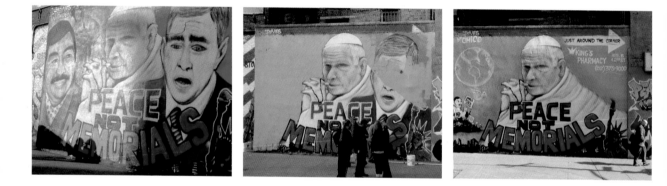

NEW YORK
USA
3.17.03
3.18.03
3.19.03
PHOTOS BY
ANETTE BALDAUF
PAT BLASHILL

TRANSFORMATION OF THE MURAL
"PEACE NOT MEMORIALS"
LOWER EAST SIDE

In the beginning, there were three. Last Sunday afternoon, Chico Garcia, a longtime artist living on the Lower East Side, had spraypainted the faces of Saddam Hussein, Pope John Paul II and President George W. Bush on the brick wall of a liquor store on the corner of Avenue B and Houston Street. Beneath their faces were the words, "Peace Not Memorials." The next day, Mr. Garcia heard that agents from the Federal Bureau of Investigation had visited the store and demanded that the image of Mr. Hussein be painted over. Asked about the episode, an F.B.I. spokesman, James Margolin, was skeptical about the credibility of the badge-bearing visitors. Be that as it may, by Tuesday, Mr. Garcia had painted over much of the mural. "I only meant to send out a positive message," he said. "Now the pope is all alone, praying for peace."

KELLY CROW JOURNALIST, THE NEW YORK TIMES

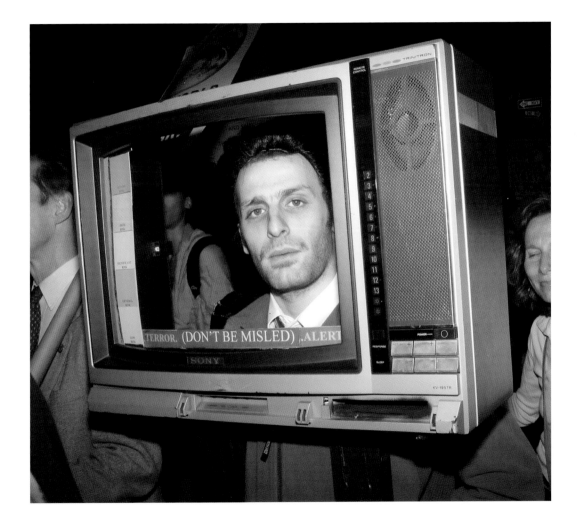

< >
NEW YORK
USA
3.22.03
PHOTOS BY
GERRIT SIEVERT

DEMONSTRATORS
ON THE STREET

A restaurant in Beaufort, North Carolina, has stopped serving french fries – or at least calling them that. "We now serve freedom fries," says owner Neal Rowland. His move recalls American anger at Germany during World War I. Back then familiar German foods such as frankfurters and sauerkraut were rechristened hot dogs and liberty cabbage.

Polls show a full one-third of Americans now hold hostile views toward France, largely as a result of its government's refusal to enforce the UN resolutions calling on Iraq to disarm and otherwise comply with the terms of the Gulf War cease-fire.

JOHN FUND JOURNALIST, THE WALL STREET JOURNAL

Freedom
Fries as
Baghdad
Burns!

takebackthe

99.5 FM
WBAI

SUPPORT
THE TROOPS
BRING THEM HOME

REPEAL THE
USA
PATRIOT
ACT

takebackthefuture.
uture.org

NEW YORK
USA
3.22.03
PHOTO BY
JENNIFER COLLINS

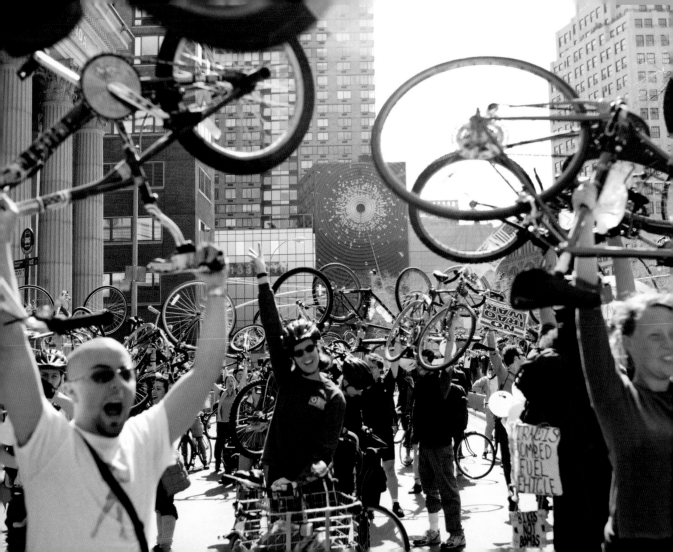

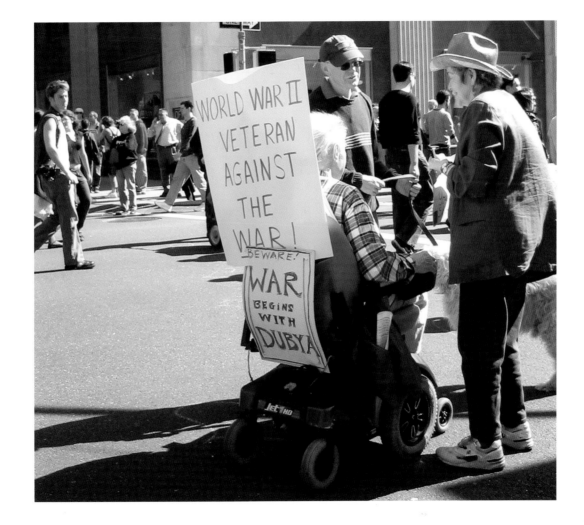

<
NEW YORK
USA
3.22.03
PHOTO BY
PETER MEITZLER

TIME'S UP! BIKE BLOCK /
ANTIWAR BIKE RIDE

>
NEW YORK, USA
3.22.03
PHOTO BY
JENNIFER COLLINS

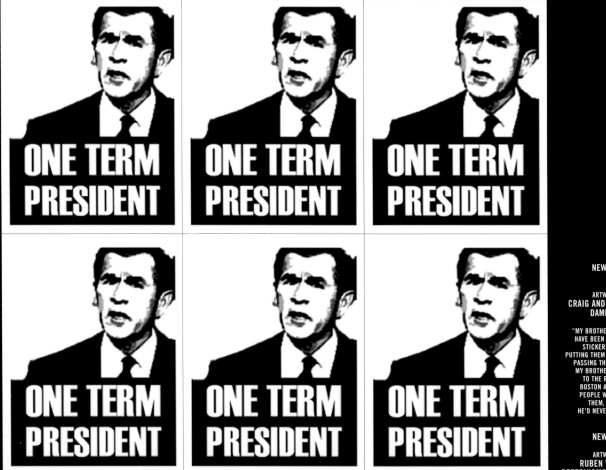

ONE TERM PRESIDENT

NEW YORK
USA
2003
ARTWORK BY
CRAIG AND NIELS
DAMRAUER

"MY BROTHER AND I
HAVE BEEN MAKING
STICKERSHEETS,
PUTTING THEM UP AND
PASSING THEM OUT.
MY BROTHER WENT
TO THE RALLY IN
BOSTON AND SAW
PEOPLE WEARING
THEM, PEOPLE
HE'D NEVER MET."

NEW YORK
USA
ARTWORK BY
RUBEN VERDU
PEEPINGMONSTER

Courage has no moral value in itself, for courage is not, in itself, a moral virtue. Vicious scoundrels, murderers, terrorists, may be brave. To describe courage as a virtue, we need an adjective: We speak of 'moral courage' — because there is such a thing as amoral courage, too. And resistance has no value in itself. It is the content of the resistance that determines its merit, its moral necessity. There is nothing inherently superior about resistance. All our claims for the righteousness of resistance rest on the rightness of the claim that the resisters are acting in the name of justice. And the justice of the cause does not depend on, and is not enhanced by, the virtue of those who make the assertion. It depends first and last on the truth of a description of a state of affairs that is, truly, unjust and unnecessary.

SUSAN SONTAG AUTHOR

WAR IS OVER!
IF YOU WANT IT

NEW YORK
USA
2.15.03
PHOTO BY
JENNIFER COLLINS

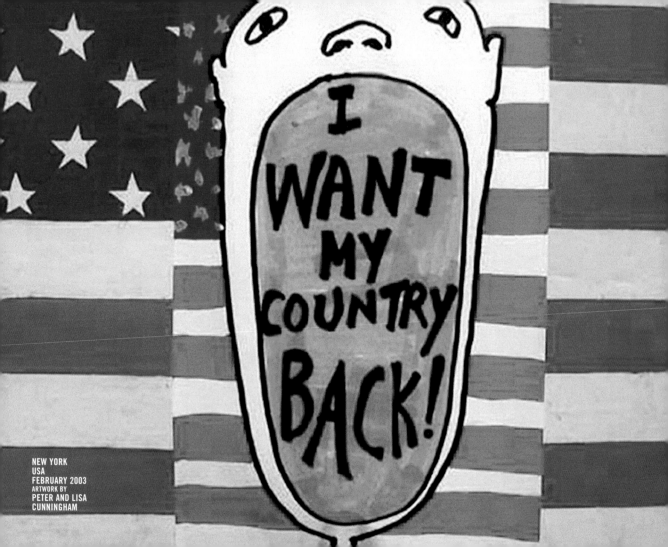

Our ability to disagree, and our inherent right to question our leaders and criticize their actions define who we are.
To allow those rights to be taken away out of fear, to punish people for their beliefs, to limit access in the news media to differing opinions is to acknowledge our democracy's defeat.

TIM ROBBINS ACTOR

Paris

The central question is: what is the state of the world? There are two visions, two analyses. Through Iraq, some think a military intervention can resolve at the same time a crisis of proliferation, part of the terrorism problem and lastly a regional crisis as big as the crisis in the Middle East. That is definitely not our analysis. The world is in great disorder. Moving forward at this point, without precaution, in a region that is already highly fractured and culturally and religiously extremely sensitive is certainly not the best way to resolve these various crises. On the contrary, we think there is a risk of misunderstanding, tension and humiliation which will only widen the gap, for example between the Arab world and the rest of the world, even though we wish to avoid this 'clash of cultures'.

DOMINIQUE DE VILLEPIN MINISTER OF FOREIGN AFFAIRS

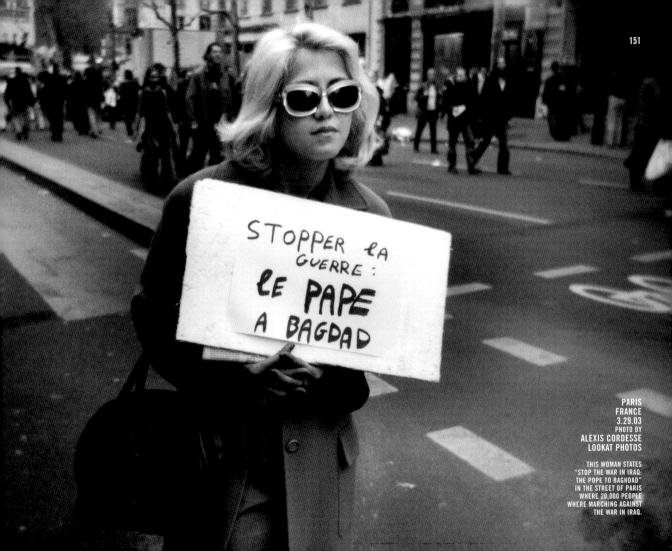

151

PARIS
FRANCE
3.29.03
PHOTO BY
ALEXIS CORDESSE
LOOKAT PHOTOS

THIS WOMAN STATES
"STOP THE WAR IN IRAQ:
THE POPE TO BAGHDAD"
IN THE STREET OF PARIS
WHERE 20,000 PEOPLE
WHERE MARCHING AGAINST
THE WAR IN IRAQ.

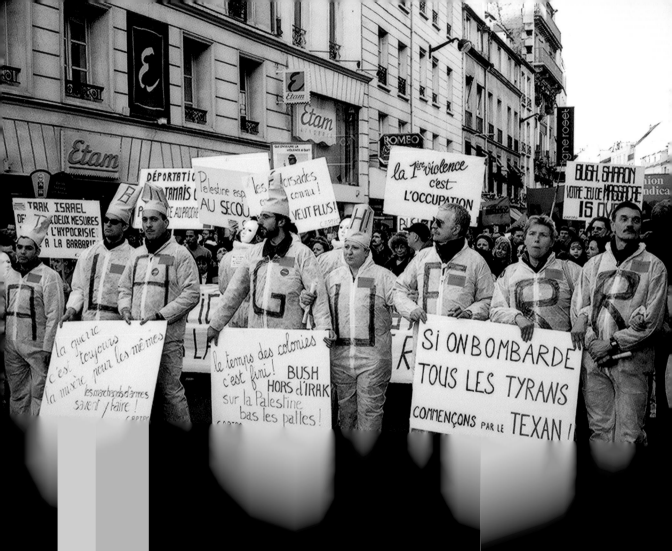

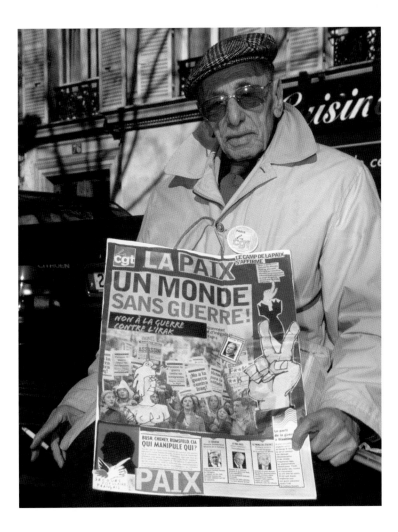

<
PARIS
FRANCE
3.15.03
PHOTO BY
ANTJE HANEBECK

>
PARIS
FRANCE
3.15.03
PHOTO BY
JULIAN FOWLER

DISPLAYING HIS HOME-MADE
SIGN, A LONG-TIME SUPPORTER
OF FRENCH LABOR UNIONS
WAITS ON THE BOULEVARD
BEAUMARCHAIS FOR THE ANTI-
WAR MARCH TO PASS BY.
ACCORDING TO FRENCH POLICE,
55,000 PEOPLE MARCHED
PROTESTING THE POSSIBLE
WAR AGAINST SADAM HUSSEIN.

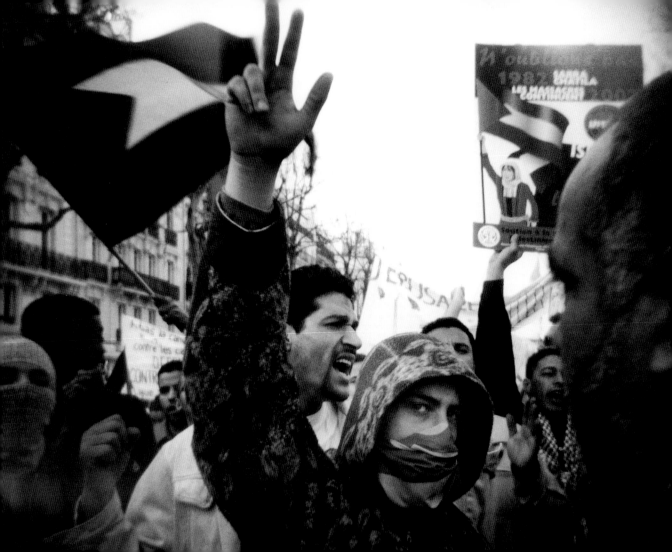

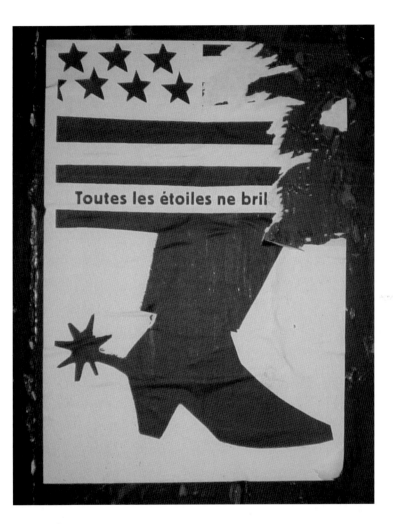

<
PARIS
FRANCE
3.22.03
PHOTO BY
ALEXIS CORDESSE
LOOKAT PHOTOS

YOUNG WOMAN WITH IRAQI
FLAG AMONG THE 100,000
PEOPLE WHO WERE DEMON-
STRATING AGAINST THE WAR
IN IRAQ, 3 DAYS AFTER THE
BEGINNING OF THE CONFLICT.

>
PARIS
FRANCE
4.8.03
PHOTO BY
SAMANTHA SACHS

"NOT EVERY STAR SHINES"

Rio de Janeiro

Thank you, President Bush. Thank you for accomplishing what very few have been able to do in this century: uniting millions of people of all continents fighting for the same cause (even if it is opposing yours). Thanks, because without you, we wouldn't have known our capacity of mobilization. Maybe it is useless at this point and time, but most likely it will be useful in the future. Thank you for allowing us, an army of anonymous people, to demonstrate on the streets trying to stop a process already begun, to know a feeling of impotence, and to learn to deal with it and transform it. Thank you for not listening to us and for not taking us seriously. But you should know that we do listen to you and do not forget your words.

PAULO COELHO AUTHOR

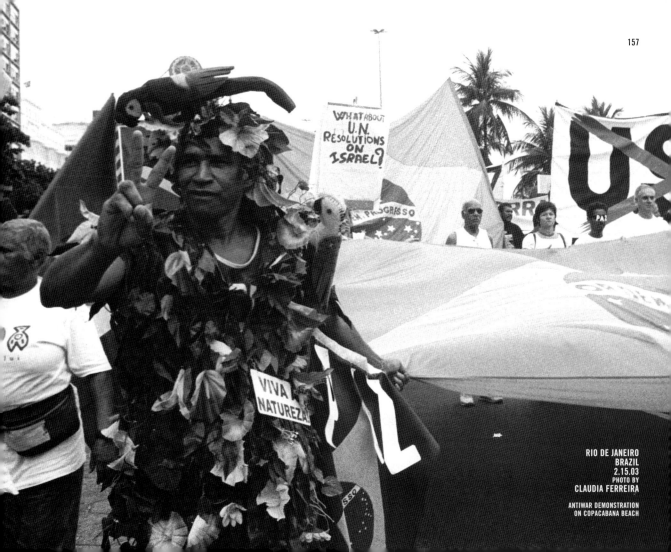

WHAT ABOUT U.N. RESOLUTIONS ON ISRAEL?

VIVA NATUREZA!

RIO DE JANEIRO
BRAZIL
2.15.03
PHOTO BY
CLAUDIA FERREIRA

ANTIWAR DEMONSTRATION
ON COPACABANA BEACH

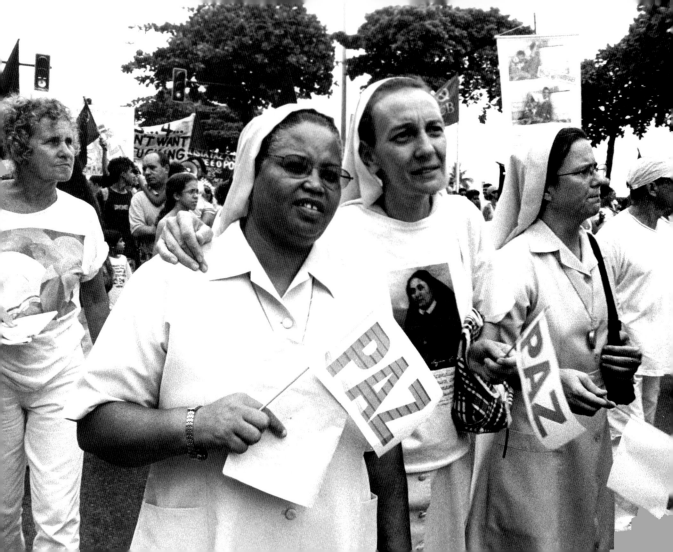

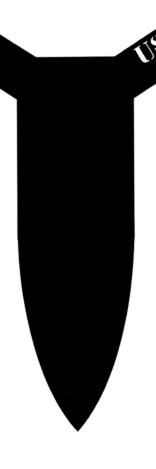

<
RIO DE JANEIRO
BRAZIL
2.15.03
PHOTO BY
CLAUDIA FERREIRA

COPACABANA BEACH

>
RIO DE JANEIRO
BRAZIL
APRIL 03
ARTWORK BY
MARCOS LEME LOPES

"CAN YOU HELP GET
MY ARMS BACK?"

ARTWORK IN HOMAGE TO
ALI ISMAEL ABBAS, 12,
SERIOUSLY INJURED AFTER
A MISSILE ATTACK, ON
4.8.2003. HE LOST ALL
HIS FAMILY AND HIS ARMS.

ali
(them)

Rome

It was one of the biggest demonstrations in Italy ever and according to estimates of the organizers more than 3 million people overflowed the streets of this historic city [Rome]. The police did not want to state numbers since it was impossible to give even a ballpark estimate of the enormous masses of people who paralyzed large parts of Rome. The main slogan was "No alla guerra, senza se senza ma" (No to war, no if's and but's) and the crowds expressed an opposing of war with or without a UN mandate. At the closing rally a list of all the countries with antiwar manifestos was read. "This kind of globalization we love," said the speaker.

WWW.WSWS.ORG ON THE PEACE DEMONSTRATION IN ROME ON 2.15.03

ROME
ITALY
3.20.03
PHOTO BY
ALESSANDRA BENEDETTI

THE ANCIENT MONUMENT
IS LIT UP BY RAINBOW
COLORS OF PEACE DURING A
CANDLELIGHT PROCESSION
AGAINST THE US ATTACK ON
IRAQ. THOUSANDS OF PEOPLE
JOINED THE SILENT PROCES-
SION TO THE COLOSSEUM TO
PROTEST AGAINST THE FIRST
BOMB ATTACK IN BAGHDAD.

163

ROME
ITALY
2.15.03
PHOTO BY
ALESSANDRA BENEDETTI

DURING THE DEMONSTRATION
AGAINST THE THREAT OF WAR
AGAINST IRAQ, A WOMAN
HOLDING A PEACE FLAG
PASSES BY ITALIAN POLICE
OFFICERS WITH HER DOG.

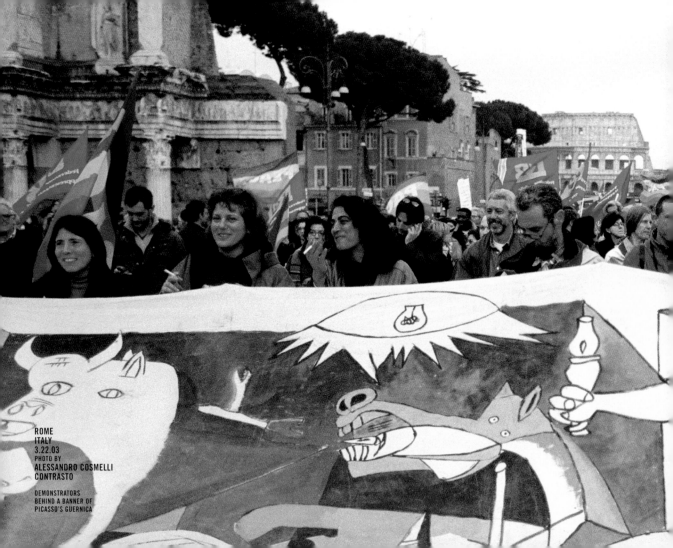

ROME
ITALY
3.22.03
PHOTO BY
ALESSANDRO COSMELLI
CONTRASTO

DEMONSTRATORS
BEHIND A BANNER OF
PICASSO'S GUERNICA

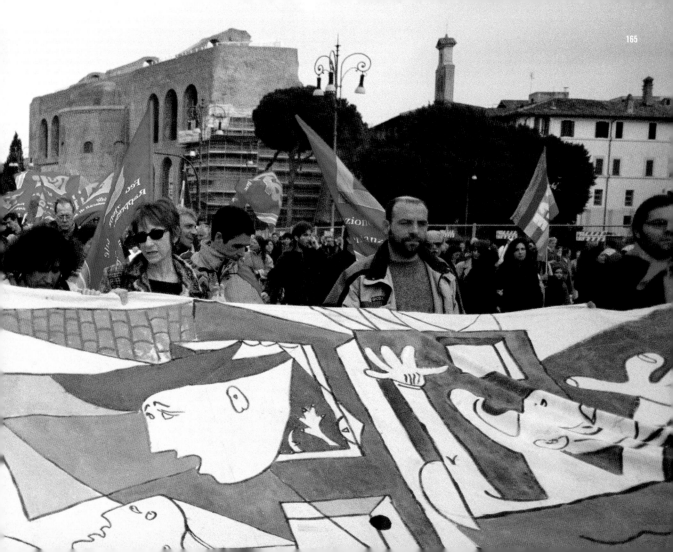

Ross Island

After a Not In Our Name gathering in October we were warned that anyone who organizes a protest demonstration or attempts to organize a union will be fired. The McMurdo Station Manager eventually told us that if we do anything of the sort, we must not give any impression that the National Science Foundation supported us in any way: no buildings, vehicles or infrastructure could be in any of our photos. When asked about ECW, the extreme cold weather gear we are issued, he told us we were not permitted to wear it in any photos we take. So we came up with the idea of the Naked Demonstration, entirely content free but conveying our strong feelings about an undisclosed issue. It was pretty chilly that day, and not just because of the weather.

ROBBIE LIBEN COMPUTER TECHNICIAN AND NETWORK ADMINISTRATOR WHO LOST HIS JOB AFTER THE DEMONSTRATION

ROSS ISLAND
ANTARCTICA
1.09.03
PHOTO BY
ROBBIE LIBEN

PROTESTING
NAKED AGGRESSION AT
MCMURDO STATION

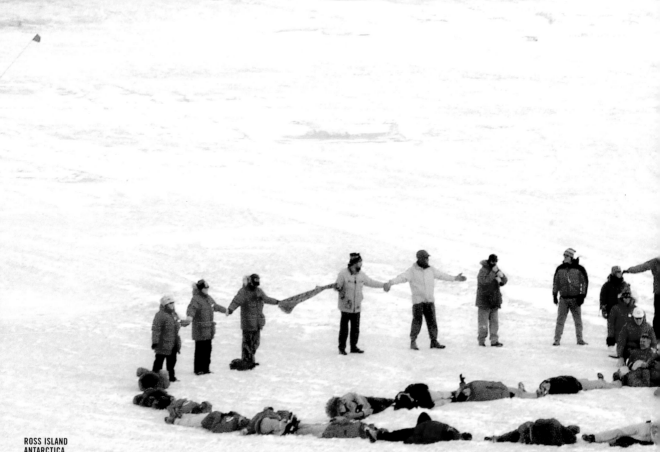

ROSS ISLAND
ANTARCTICA
2.15.03
PHOTO BY
JOAN MYERS

PEACE SIGN AT MCMURDO
STATION, ANTARCTICA

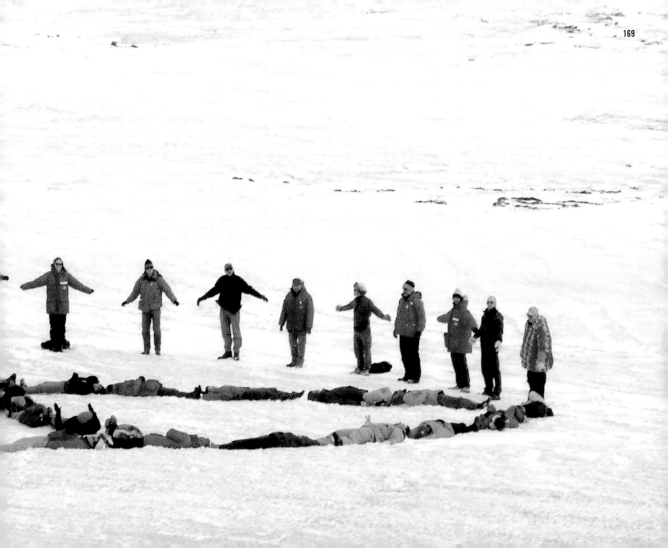

San Francisco

Are we 'only' 5%, 10%, of the population? Isn't that five to ten million adults? One percent? A million. More than that were in demonstrations in this country alone as part of a far larger global movement, the largest worldwide protest ever seen before or during any war! That's enough activists to move and change any country in the world, even (with courage) a police state. And we're far from that, yet. We can avert that real danger if we continue using to the fullest all the freedoms we still have.

DANIEL ELLSBERG LECTURER, WRITER AND ACTIVIST

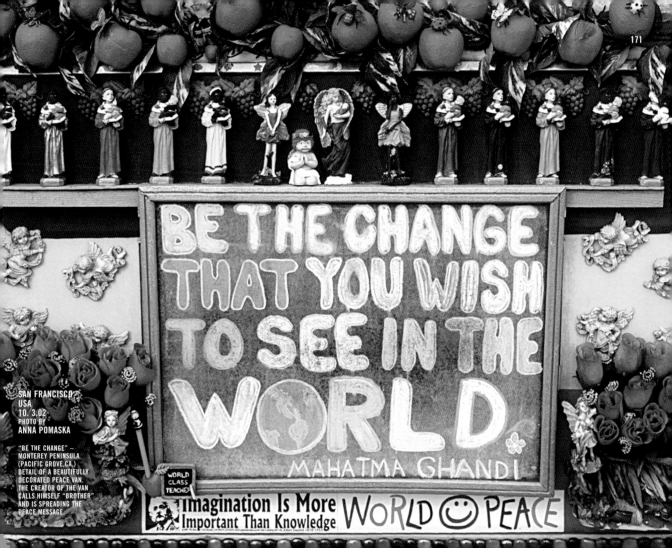

171

BE THE CHANGE
THAT YOU WISH
TO SEE IN THE
WORLD.
— MAHATMA GHANDI

SAN FRANCISCO
USA
10. 3.02
PHOTO BY
ANNA POMASKA

"BE THE CHANGE" —
MONTEREY PENINSULA
(PACIFIC GROVE, CA.)
DETAIL OF A BEAUTIFULLY
DECORATED PEACE VAN.
THE CREATOR OF THE VAN
CALLS HIMSELF "BROTHER"
AND IS SPREADING THE
PEACE MESSAGE.

WORLD CLASS TEACHER

Imagination Is More
Important Than Knowledge

WORLD ☺ PEACE

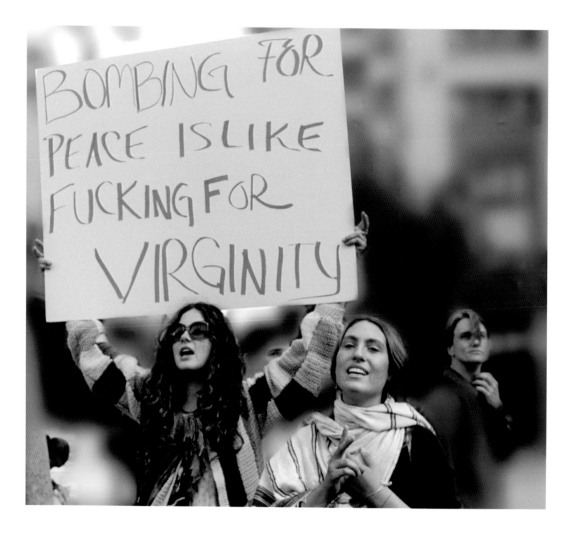

BOMBING FOR PEACE IS LIKE FUCKING FOR VIRGINITY

SAN FRANCISCO
USA
10.26.02
PHOTO BY
ANNA POMASKA

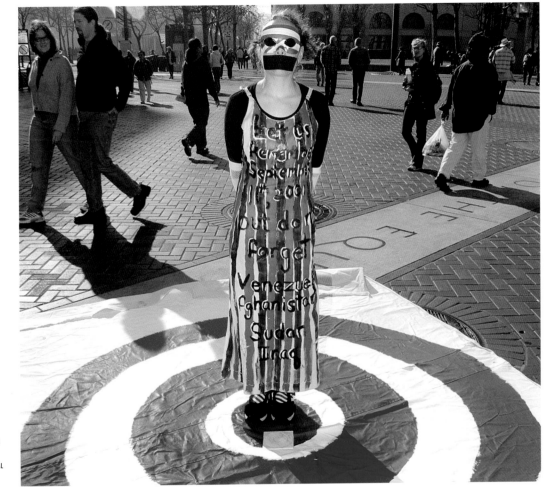

SAN FRANCISCO
USA
1.18.03
PHOTO BY
**LONNY SHAVELSON
ZUMA PRESS**

IN SAN FRANCISCO, IN A
SISTER MARCH TO ONE IN
WASHINGTON, D.C., TENS OF
THOUSANDS OF DEMONSTRA-
TORS MARCHED AGAINST A
POSSIBLE WAR IN IRAQ.
THE MARCHERS PROTESTED
AGAINST GOING TO WAR TO
REMOVE SADDAM HUSSEIN,
AND ASKED THAT THE BILLIONS
OF DOLLARS THAT WOULD BE
SPENT ON THAT WAR INSTEAD
BE SPENT ON DOMESTIC SOCIAL
PROGRAMS. A GIRL AWAITS
THE BOMBING.

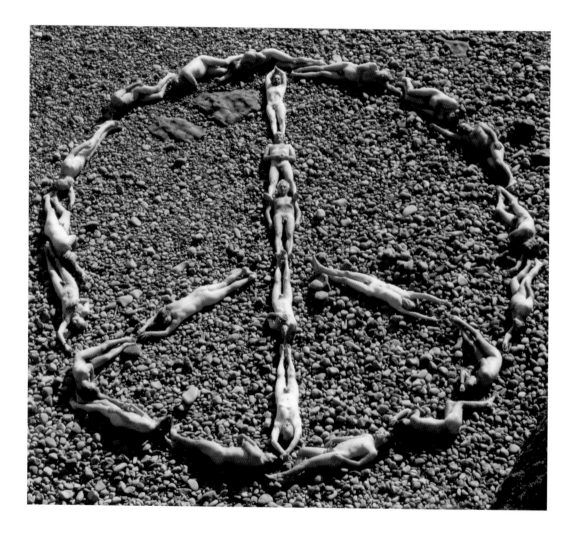

DRAKE'S BEACH
POINT REYES
USA
12.29.02
PHOTO BY
CHRISTOPHER
SPRINGMANN
BARINGWITNESS.ORG

THE PEACE AND
PARTNERSHIP
MOVEMENT,
BARINGWITNESS.ORG
CONCEPT AND
ORGANIZATION
BY DONNA SHEEHAN

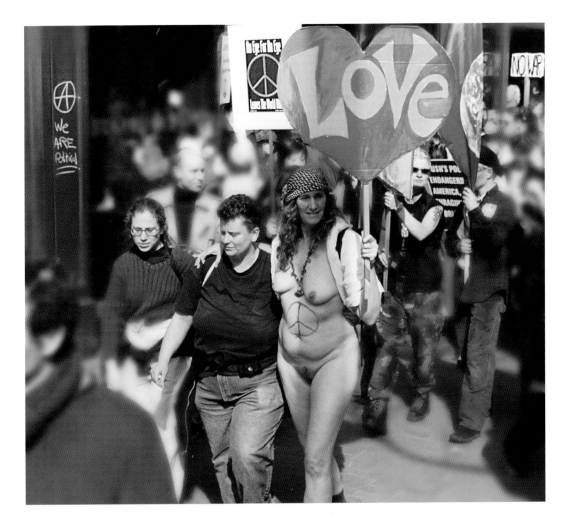

SAN FRANCISCO
USA
2.16.03
PHOTO BY
ANNA POMASKA

THE STREET HAD BECOME
SO CONGESTED THAT I WAS
STANDING ON A NEWSPAPER
VENDING MACHINE TO SEE
BETTER. I LOOKED BEHIND
ME AND SAW THESE WOMEN
WALKING PARALLEL TO THE
MAIN PARADE.

Santiago de Chile

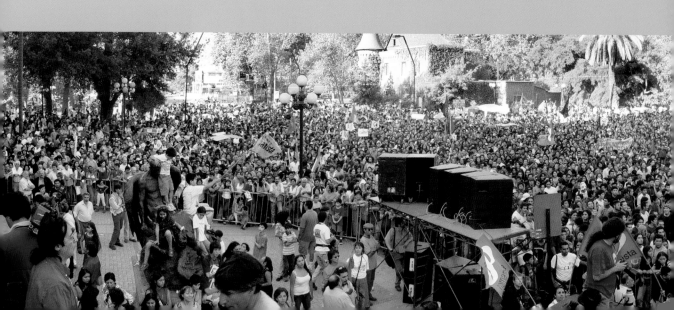

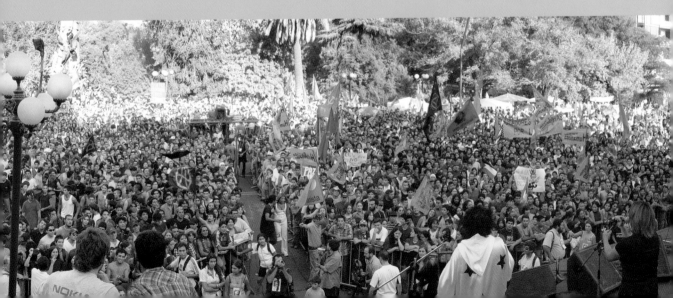

SANTIAGO DE CHILE
CHILE
2.15.03
PHOTO BY
RAFAEL EDWARDS
ANTOJA ART COLLECTIVE

THIS PANORAMIC VIEW
SHOWS THE LARGE CROWD
OF AROUND 15,000 PEOPLE
ASSEMBLED IN CHILE TO
PROTEST THE INVASION OF IRAQ.

Seoul

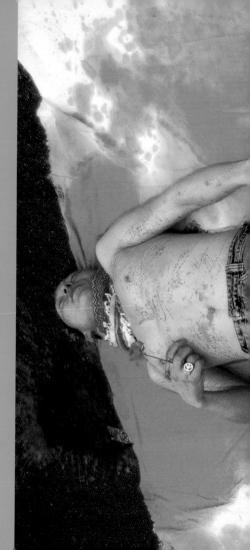

SEOUL
SOUTH KOREA
4.12.03
PHOTO BY
HAK RI-KIM
KEYSTONE PRESS
ZUMA PRESS

YOUNG KOREAN PROTESTER IS
DOING A PERFORMANCE THAT
EXPRESSES WAR SUFFERING.
THOUSANDS GATHERED TO
PROTEST THE WAR IN IRAQ AND
SOUTH KOREA'S DECISION TO
SEND 600 NON-COMBAT
TROOPS TO THE GULF TO
SUPPORT THE COALITION.

Stuttgart

Hundreds of thousands of Germans demonstrate against the American movement against Iraq. Among them are many teenagers who otherwise barely show an interest in politics, and who practice democracy in this context for the first time. This generation – often labeled unpolitical – stands up and develops unexpected potential. But their protests are not only for peace. They're also directed against the USA, caused by disapointment in regard to other political issues, for example environmental protection policies. This makes it even more important for German politicians to initiate a critical dialogue with the USA, one that is accepted by politicians there. Should this dialogue not happen, this criticism could develop into Anti-Americanism. Today's teenagers are tomorrow's decision-makers.

HINRICH KÖTTER GERMAN CITIZEN, FROM A LETTER TO THE EDITOR, DIE ZEIT, 3.4.2003

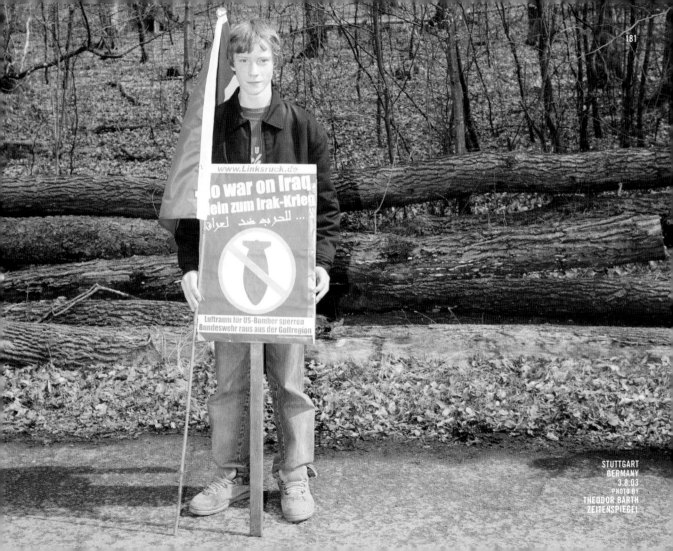

www.Linksruck.de

o war on Iraq
ein zum Irak-Krieg

... للحرب ضد لعراق

Luftraum für US-Bomber sperren
Bundeswehr raus aus der Golfregion

STUTTGART
GERMANY
3.8.03
PHOTO BY
THEODOR BARTH
ZEITENSPIEGEL

Sydney

For all the achievements of the movement against the Vietnam War, it did not get underway until four years after the Americans had invaded. Today, under countless banners, from the anti-globalization movement to the Stop the War campaign, the new movement, drawing millions all over the world, may well be the greatest. We need it urgently.

JOHN PILGER AUTHOR AND FILMMAKER

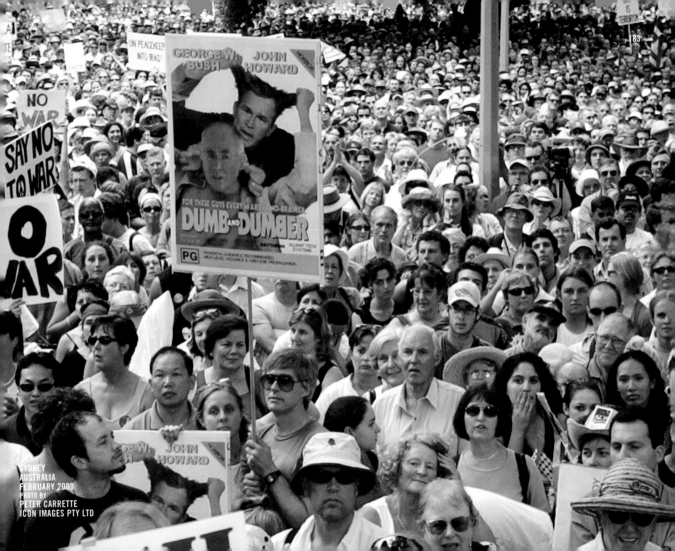

83

NO WAR
SAY NO TO WAR
O WAR

GEORGE W. BUSH JOHN HOWARD

FOR THESE GUYS EVERY WAR'S A NO-BRAINER
DUMB and DUMBER

PG

JOHN HOWARD

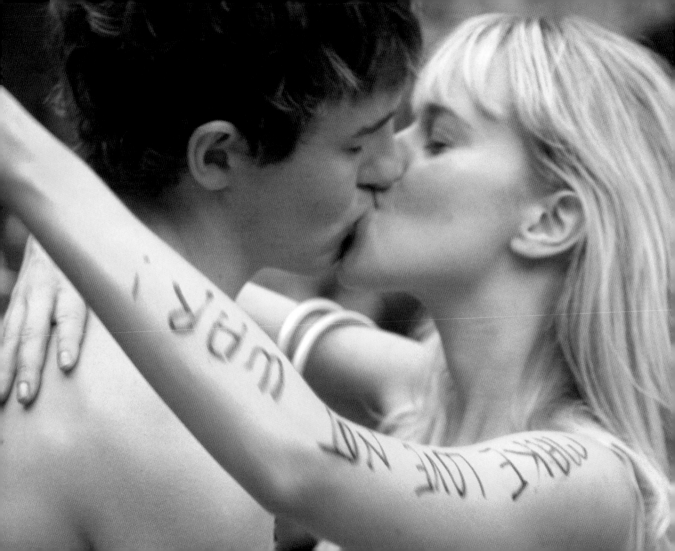

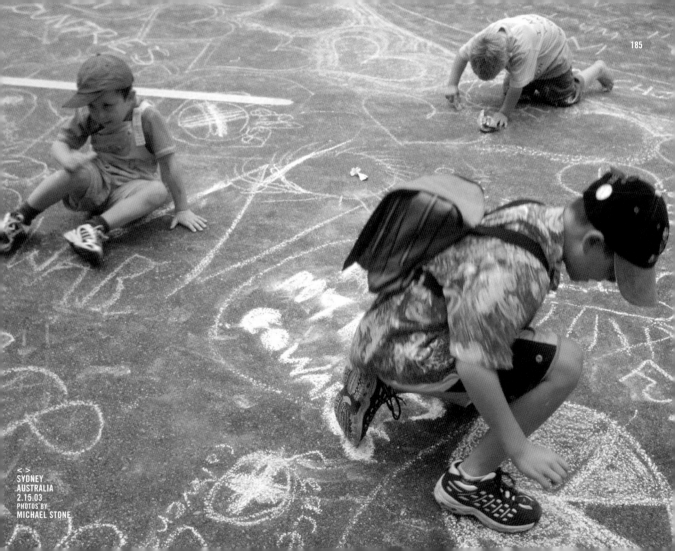

<>
SYDNEY
AUSTRALIA
2.15.03
PHOTOS BY
MICHAEL STONE

Tehran

The war with Iraq, regardless of its outcome,
will be one of those turning points in human history
like the defeat of Persians at Marathon, the battle
of Waterloo, the defeat of crusaders in the hands
of Saladin, and the Mongol invasion.
This conflict is the biggest flash point between
the modern Western civilization and the Islamic
civilization that the West, and the U.S. in particular,
has been hoping to avoid for a long time.
But now, the time has come and we must act
or face the consequences, as did the great
empires before us.

HAMID BAHADORI WWW.IRANIAN.COM

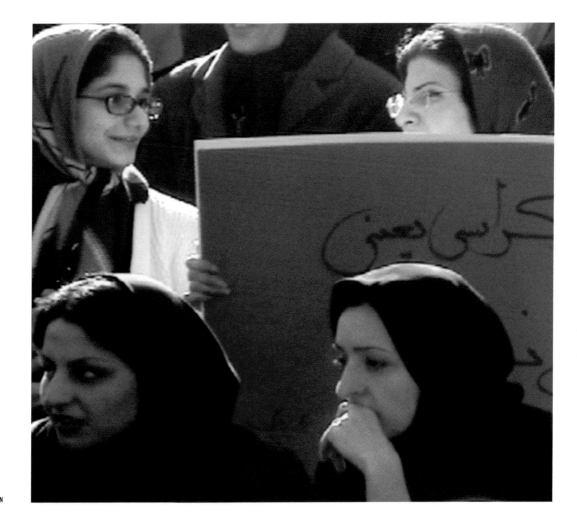

**TEHRAN
IRAN
3.8.03
PHOTO BY
BAHAREH HOUSSEINI**

IRANIAN WOMEN AROUND
A PLACARD READING
"DEMOCRACY MEANS
PEACE NOT WEAPONS"
AT A WOMEN'S PEACE
DEMONSTRATION IN TEHRAN

Tel Aviv

Truth is the first victim of any war. But it seems that in this particular war it suffers even more than usual. Mendacity, hypocrisy, dis-information, and plain brainwashing are having a ball. Four-star generals parrot manifestly mendacious slogans, star-journalists from all over the world accept them eagerly, world TV networks repeat them diligently and the Israeli media lap it all up. Bon appetit.

URI AVNERY AUTHOR

TEL AVIV
ISRAEL
4.2.03
PHOTO BY
KEVIN UNGER
ZUMA PRESS

ISRAELI ARABS PROTEST
OUTSIDE THE US EMBASSY
AGAINST THE AMERICAN
LED WAR ON IRAQ.

Tlaxcala

Yes, there is a clash of civilizations.
But not the kind that pits Islam against the West,
North against South, or the US ("single surviving
model of human progress") against all the rest (ourselves).
It's the clash between authoritarian, ignorant, exclusive
power born of brute force, and democratic, wise, and
inclusive power that springs from human creativity.
Do we know how to resist? Do we know how to choose?
War is not peace. Freedom is not slavery.
Ignorance is not strength.

CARLOS FUENTES AUTHOR [AUTODAFE.ORG]

**TLAXCALA
MEXICO
3.4.2003
PHOTO AND
INTERVENTION BY
PEDRO PARDO**

"LET'S DYE THE FOUNTAINS
IN RED, NO MORE BLOOD
FOR OIL – AGAINST THE
INVASION IN IRAQ"

THE INITIATIVE OF TINTING
THE FOUNTAINS RED WAS
PART OF A PAN-LATIN CAM-
PAIGN THAT INCLUDED SPAIN,
ARGENTINA, MEXICO, AND
CHILE. IT WAS A SHARED
INITIATIVE BY ARGENTINIAN
VISUAL ARTIST MARCELO
BRODSKY, FOTOGRAFOS Y
PERIODISTAS POR UN MUNDO
SIN GUERRAS, A SPANISH
ORGANIZATION, AND THE
ASSOCIATION OF VISUAL
ARTISTS OF MADRID, SPAIN.
IT WAS CONTINUED IN
ARGENTINA BY THE ASOCIACIÓN
DE ARTISTAS VISUALES DE
ARGENTINA.

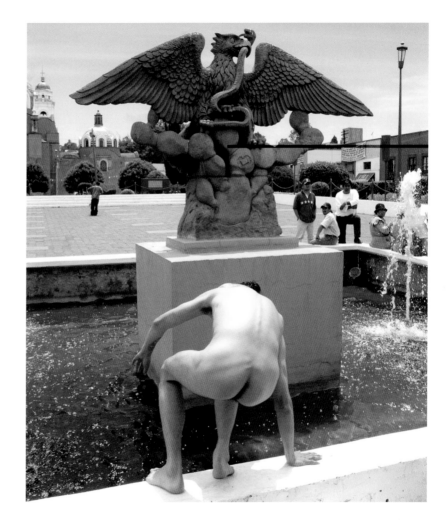

Tokyo

In Tokyo, we experienced the largest demonstration since the '80s. The number of people who participated was relatively small, compared with other cities such as New York or Paris, but this must be an important step for us, especially for younger generations, who just start to learn how to express themselves openly.

YASUHIRO OGAWA PHOTOGRAPHER

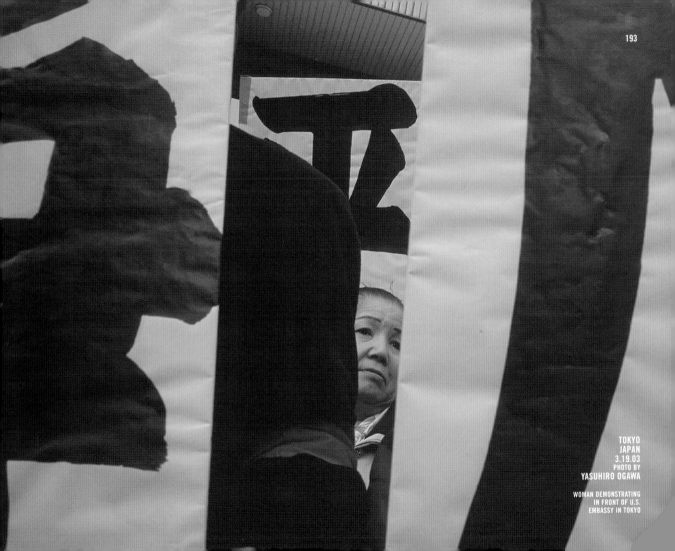

TOKYO
JAPAN
3.19.03
PHOTO BY
YASUHIRO OGAWA

WOMAN DEMONSTRATING
IN FRONT OF U.S.
EMBASSY IN TOKYO

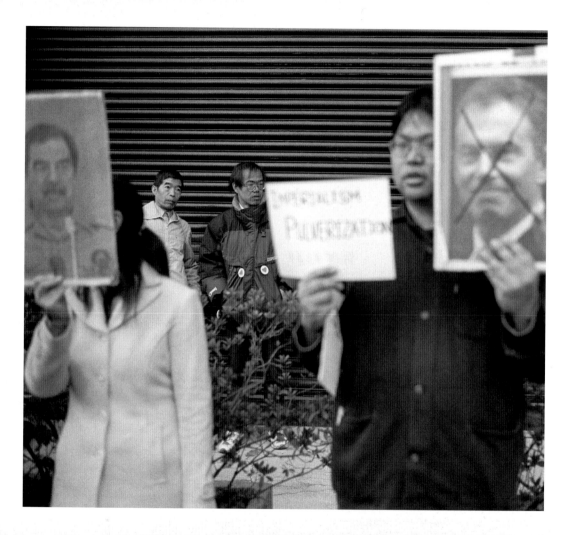

< >
TOKYO
JAPAN
3.21.03
PHOTOS BY
ANDREAS SEIBERT
LOOKAT PHOTOS

ANTIWAR DEMONSTRATION
IN FRONT OF THE US
EMBASSY IN TOKYO

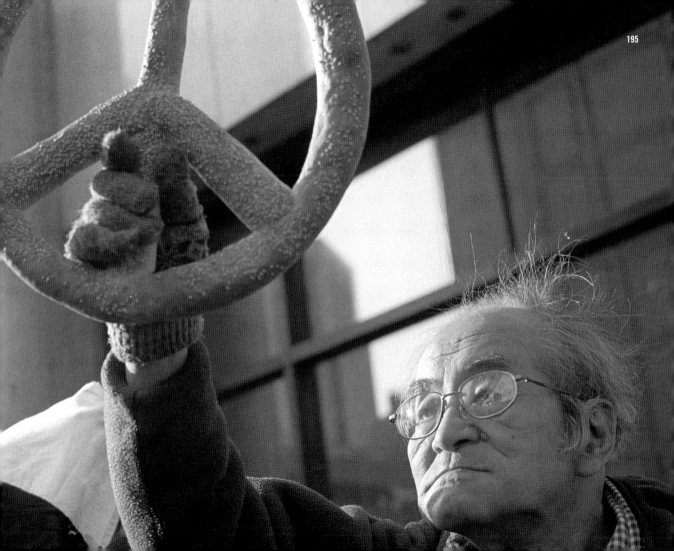

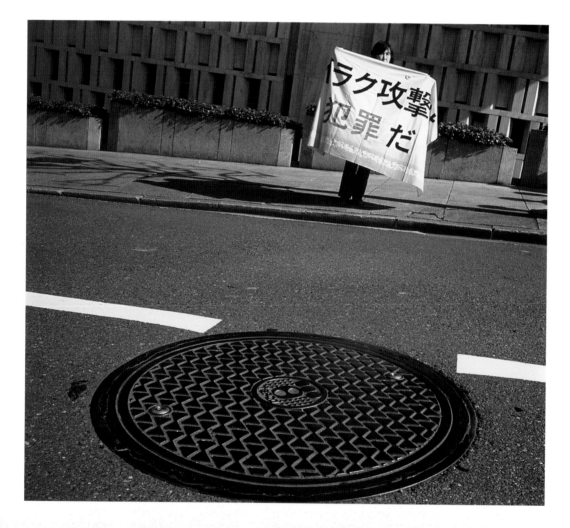

ラク攻撃は犯罪だ

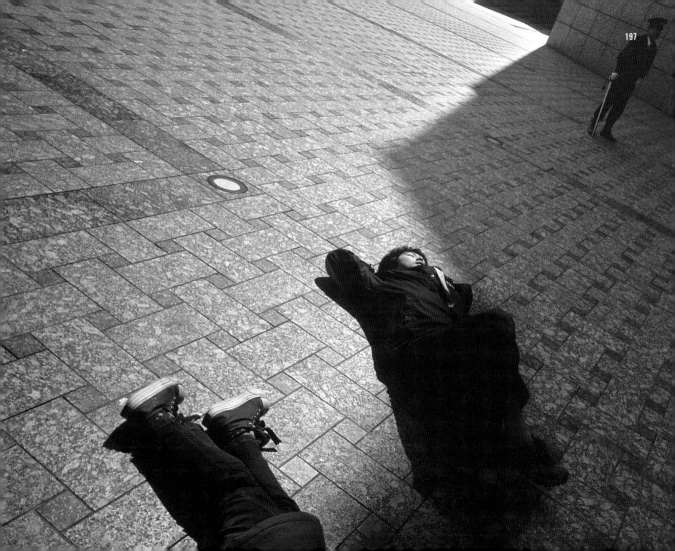

Toronto

I was born in a country [Czechoslovakia] which was attacked by Germans in 1939 and Russians in 1968. I wish Americans joined the war in Europe earlier so many of my relatives would have been saved. I wish they would have come to help us in 1968 so I could have continued to live in Europe. How many Iraqi lives were saved by Americans? More than there are naïve protesters in the world. Grow up!

YURI DOJC PHOTOGRAPHER

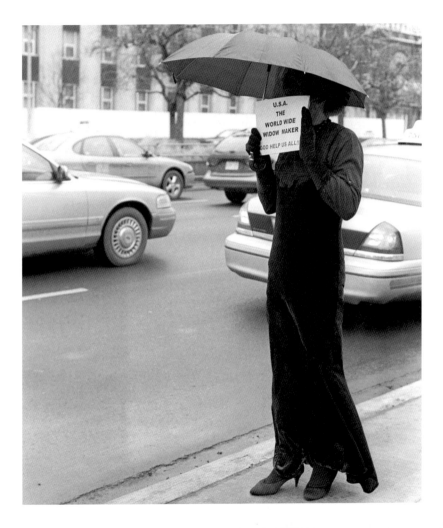

**TORONTO
CANADA
PHOTO BY
DOUG MACLELLAN**

A TRANSVESTITE DRESSED AS
A WIDOW PROTESTS AT THE
START OF THE SECOND US
WAR IN IRAQ OUTSIDE THE US
CONSULATE IN TORONTO.

Vancouver

The Canadian Government has opened
a toll-free number so all Canadians can
call the Canadian Foreign Affairs Department,
Iraq Desk, and tell our democratically elected
Government what you think Canada's stand should
be regarding the military intervention in Iraq.
The toll-free number is: 1-866-880-4378.

STOPWAR.CA/ARTICLES 4.2.2003

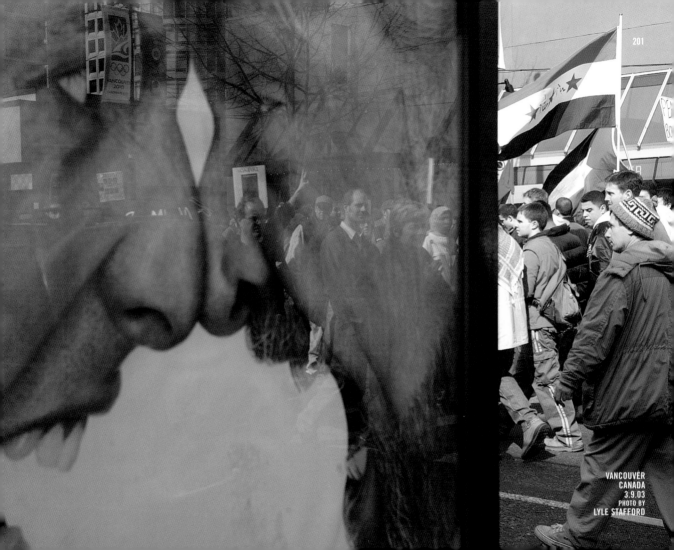

VANCOUVER
CANADA
3.9.03
PHOTO BY
LYLE STAFFORD

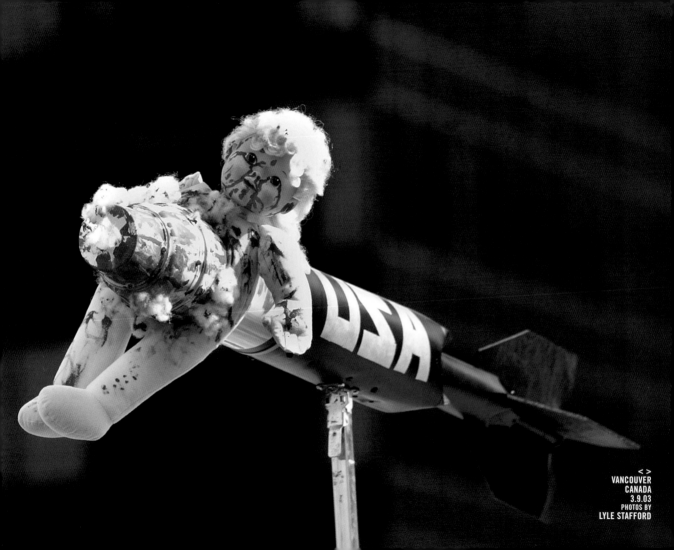

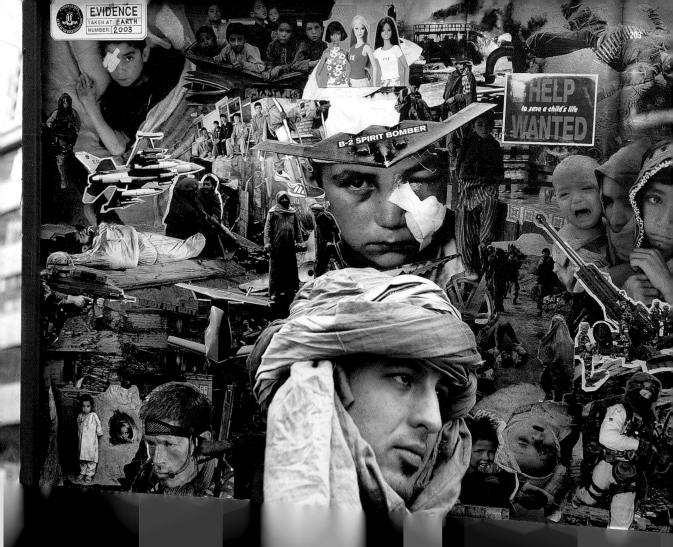

Washington DC

Those who make peaceful
revolution impossible
will make violent
revolution inevitable.

JOHN F. KENNEDY FORMER PRESIDENT OF THE UNITED STATES

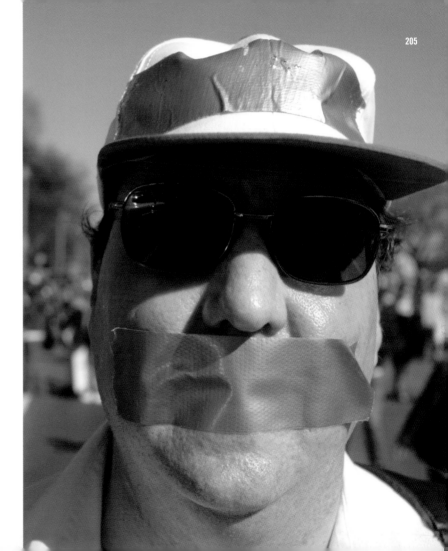

WASHINGTON DC
USA
3.15.03
PHOTO BY
DANIEL MARRACINO

HE WAS TRYING TO TAKE
THE TAPE OFF BUT HIS
HANDS WERE TIED

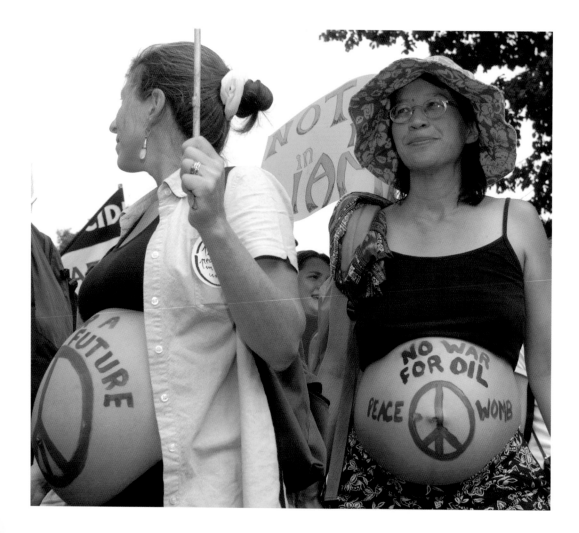

<
WASHINGTON DC
USA
9.29.03
PHOTO BY
**ISAAC MENASHE
ZUMA PRESS**

TWO PREGNANT ANTI-WAR
DEMONSTRATORS FOUND A
CREATIVE WAY TO DISPLAY
THEIR MESSAGE DURING A
MARCH THROUGH EMBASSY
ROW ON MASSACHUSETTS
AVENUE IN WASHINGTON D.C.
ON THEIR WAY TO THE VICE
PRESIDENT'S RESIDENCE.

>
WASHINGTON DC
USA
3.15.03
PHOTO BY
DANIEL MARRACINO

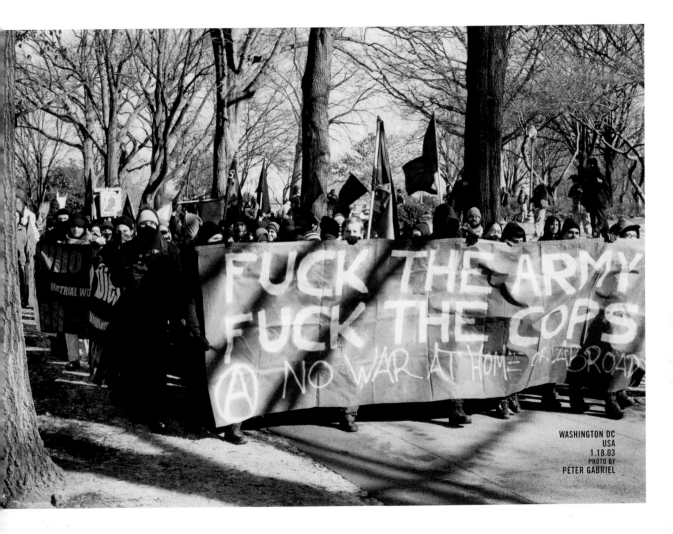

FUCK THE ARMY
FUCK THE COPS
Ⓐ NO WAR AT HOME or ABROAD

WASHINGTON DC
USA
1.18.03
PHOTO BY
PETER GABRIEL

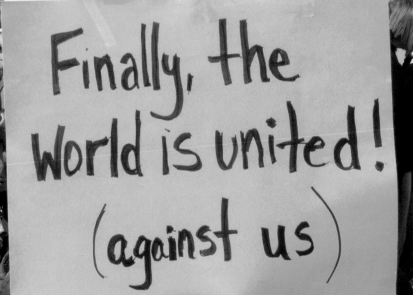

Finally, the
World is united!
(against us)

Our Nation's cause has always been larger than our Nation's defense. We fight, as we always fight, for a just peace — a peace that favors liberty. We will defend the peace against the threats from terrorists and tyrants. We will preserve the peace by building good relations among the great powers. And we will extend the peace by encouraging free and open societies on every continent.

GEORGE W. BUSH
PRESIDENT OF THE UNITED STATES OF AMERICA ON THE NATIONAL SECURITY STRATEGY OF THE UNITED STATES, 6.1.2002

February 15th was freezing in New York. I was not looking forward to a cold day on city streets. The subway was crowded and no fun to board, especially with the recent ratchet up from yellow to orange on the US government's alert scale. I had to fight my way through the doors to get to the demonstration. Looking around, I noticed everyone carried signs. I started reading the messages and realized we were all here for the same reason: to say no to a pending war that seemed unjust, imperialistic, and dangerous.

We had all witnessed a period of incredible change: our city had been attacked and our vulnerability exposed. To overcome the tragedy of 9/11, Americans united. The once politically diverse spirit of the US gave way to blind patriotic conformism.

As the pending war grew near yet another dynamic was born. "You're either with us, or against us," was the phrase of the day that epitomized the new worldwide polarization.

Stepping onto Third Avenue, I experienced a new kind of unity. There were a reported 1/2 million people on the streets of New York that day. We filled the avenues and streets, united in peace, for peace. We finally had a chance to act on our emotions by speaking out against more violence. The overwhelming spirit of the day made us all feel strong, capable, hopeful, and proud of New York, New Yorkers and America. It was a feeling every protestor wanted to hang onto.

The next day emails poured in from friends with stories and photographs from the marches all over the world. An estimated 30 million people had participated in protests worldwide. It was incredible. I wanted to document this day. I decided to make a book.

On March 1st I had a first mock-up, a handful of pages filled with photographs from the New York protest. But it was enough to inspire Mareile Fritzsche,

our brilliant and restless photo editor, MaryAnn Camilleri, publishing director with a whip, and Barbara Sauermann, proactive editor and researcher to join forces.

With this team, 2/15 turned into a real project. We reached out to assemble information, support, and critical feedback. We collected more, learned more, and edited more. Through our call for entries and our website, we received thousands of photographs from over forty countries worldwide.

An overwhelming amount of submissions came from New York, the birthplace of this project. Therefore, this city forms the biggest chapter.

The selection of photographs and quotes in 2/15 attempts to preserve the diversity of moments and messages during the protests worldwide. Many great photographs, locations and statements could not be included — editing remained the biggest challenge.

The creation of 2/15 would not have been possible without the tremendous support of all contributors, friends, and professional advisers. Our thanks go out to all of them. We especially appreciate the kind and visionary guidance provided by our co-publisher AK Press.

Remember and share an important day in world history. There are many ways to read this book. Enjoy it.

CONNIE KOCH ORIGINATOR OF 2/15 AND FOUNDING PARTNER OF HELLO [NYC]

Contributors

thanks to all for
contributing their work
and their words to 2/15,
especially to those
whose submissions
could not be included

ANTARCTICA
MELANIE CONNER
ROBBIE LIBEN
JOAN MYERS
RICK STERLING
ARGENTINIA
MARCELO BRODSKY
LEON FERRARI
AUSTRALIA
GRAEME BATTERBURY
LISA CARRETTE
PETER CARRETTE
ELIO LOCCISANO
ELISA PEARL BLYNN
MICHAEL STONE
AUSTRIA
MARCELL NIMFUEHR
BANGLADESH
ABIR ABDULLAH
MONIRUL ALAM
MUHAMMAD KADER
BELGIUM
JÖRN SACKERMANN
DRIES VAN NOTEN
BRAZIL
YOMAR AUGUSTO
CLAUDIA FERREIRA
MARCOS LEME LOPES
CANADA
COLIN CORNEAU

YURI DOJC
TODD KRAKOWSKI
DOUG MACLELLAN
JOHN SIMPSON
LYLE STAFFORD
TRICIA TIMMERMANS
BERNARD WEIL
ZUMA PRESS
CHILE
ANTONJA ART COLLECTIVE
MARCELO BRODSKY
RAFAEL EDWARDS
FOTOGRAFOS MUNDO SIN GU
CHINA
JOHN CHOY
BOBSY GAIA
CUBA
NELSON R. DE ARELLANO
MORITZ NEUMUELLER
DENMARK
FRANCIS DEAN
ROLANDO DIAZ
THE IMAGE WORKS
EGYPT
FELTZ
THE IMAGE WORKS
TOPHAM
WALID WASSEL KAZZIHA
FINLAND
PETTERI SULONEN

FRANCE
ALEXIS CORDESSE
PRISCILLA FATTELAY
JULIAN FOWLER
GABOU
ANTJE HANEBECK
LOOKAT PHOTOS
KEIRON O-CONNOR
JOSEPH RABIE
CHANTAL RUSSELL LE ROUX
SAMANTHA SACHS
DIDIER SAULNIER
THE IMAGE WORKS
ZUMA PRESS
GERMANY
ACTION PRESS
THEODOR BARTH
MICHAEL ELLIS
ROLF GIBBS
GÜNTER GRASS
KORBINIAN GREINER
CHRISTIANE GUDE
TOBIAS HABERL
ANDREAS HERZAU
MARIA HOFFMANN
CHRISTIAN JUNGEBLODT
HINRICH KÖTTER
SANDRA MEISEL
GERHARD NECKER
NIBOR

TOBIAS ROTHE
MARTIN RÜSTER
MICHAEL RUSSEL
MARTIN SASSE
LEXI SCHLEBER
PETER SCHULTE
FRANK SCHULTZE
AMI SIOUX
SNAPS
FERDINAND SPANNAN
MARCO URBAN
NANA YURIKO
ZUMA PRESS
GREECE
KATHRYN BLUME
SHARRON BOWER
LIZZIE CALLIGAS
NICHOLAS KAMTSIS
CHRISTOS KOPSAXILIS
MARIA PAPADIMITRIOU
ZUMA PRESS
HUNGARY
GYÖRGY KONRÁD
ICELAND
THORDIS CLAESSEN
INDIA
FAWZAN HUSAIN
PHOTOINK
ARUNDHATI ROY
AMI VITALE

INDONESIA
SINARTUS SOSRODJOJO
ZUMA PRESS
IRAN
BAHAREH HOUSSEINI
IRAQ
LAIF IMAGES
MARTIN SASSE
ISRAEL
URI AVNERY
PALESTINE-ISRAEL JOURNAL
HILLEL SCHENKER
ZUMA PRESS
ITALY
ACTION PRESS
ALESSANDRA BENEDETTI
MAURO COLELLA
CONTRASTO
ALESSANDRO COSMELLI
ALFREDO FALVO
GRANATA
ARICI GRAZIANO
MARCO MERLINI
PHILIPPE PACHE
FABRIZIO PESCE
LA PRESSE
BRUNA ORLANDI
THE IMAGE WORKS
ALESSANDRO TOSATTO
ZUMA PRESS

JAPAN
FUJIFOTOS
LOOKAT PHOTOS
YASUHIRO OGAWA
ANDREAS SEIBERT
THE IMAGE WORKS
MEXICO
CARLOS FUENTES
PEDRO PARDO
THE IMAGE WORKS
NETHERLANDS
WILLEM POELSTRA
PAKISTAN
DEANPICTURES
AKHTAR SOOMRO
THE IMAGE WORKS
RUSSIA
KOMMERSANT
DMITRY LEKAY
ILYA PILATEV
ZUMA PRESS
SCOTLAND
A.L. KENNEDY
ALAN WILSON
SOUTH AFRICA
RALF HUETTNER
ERIC MILLER
SOUTH KOREA
FUJIFOTOS
JERRY ISAACS

KEYSTONE PRESS
CHARLY KIM
HAK RI-KIM
RYU SEUNG IL
THE IMAGE WORKS
WSWS.ORG
ZUMA PRESS
SPAIN
ALEJANDRO CHEREP
JUANJO FERNANDEZ
ALBERTO FOYO
ALVARO GARCIA
MIGUEL ANGEL INVARATO
CHANTAL LE ROUX
JUAN PEGORARO TERMINI
JOSÉ ANTONIO ROJO
MARTIN RÜSTER
JOSÉ SARAMAGO
RUBEN VERDU
SWEDEN
SVANTJE ÖRNBERG
SWITZERLAND
PETER GERBER
THOMAS GERMANN
FRANZISKA HERRMANN
GERMANN
ADRIAN MOSER
PHILIPPE PACHE
PLAKATE GEGEN DEN KRIEG
DANIEL RHIS

FRANZISKA SCHEIDEGGER
GUIDO VORBURGER
TURKEY
SEVIL DELIN
DEVRIM NAS
ORKAN PAMUK
AMI VITALE
UNITED KINGDOM
NEIL BURGESS
KRISTIAN BUUS
VICTOR COSTA
SOPHIA EVANS
ROBERT HACKMAN
JESS HURD
OLIVER JAMES
MELY LERMAN
MAGGIE LYNAS
A.L. KENNEDY
NBPICTURES
PRESSNET
KAREN ROBINSON
PAUL ROGERS
JOHN SIMPSON
ANTHONY R. SLEEP
MICHALIS SOURLIS
DAVID STEVENS
THE IMAGE WORKS
TOPHAM
SIMON TYSKO
MANUELA WYSS

USA

MIREYA ACIERTO	LOU DEMATTEIS	ED KASHI	SEBASTIAN PIRAS
RITA ALFONSO	BRYAN DENTON	JOHN KORTY	ANNA POMASKA
MARC ANDERSON	LOUIS DE SIPIO	JOHANNES KROEMER	MARINA POTOK
ALICE ARNOLD	KAREN DETRICK	ANDY KROPA	ANA PRVACKI
SIMONA ARU	RALPH EISMAN	JACK KURTZ	TIM ROBBINS
FRED ASKEW	DANIEL ELLSBERG	BRANIMIR KYARTUC	JOHN ROBINSON
ANETTE BALDAUF	ROMAN ELSENER	BARBARA LANDI	SEAN RODRIGUEZ
CHRISTOPH BANGERT	STEFAN FALKE	RENÉE LANDUYT	MEL ROSENTHAL
MARIAN BENES	IRENE FERTIK	CATI LAPORTE	LUCIEN SAMAHA
NATHAN BLANEY	DON FRENCH	MARC LEPSON	JONATHAN SCHELL
PAT BLASHILL	CONNIE FRISBEE HOUDE	DONNA LIEBERMAN	KLAUS SCHOENWIESE
JULIE BLATTBERG	FLORIAN FRITZSCHE	MARK LUDAK	FRANK SCHULTZE
JEFFREY BRAVERMAN	JULIAN FOWLER	CHRISTIAN LUTZ	ROBERT SERGEL
BORIS BREUER	JOHN FUND	JOSH MACPHEE	LONNY SHAVELSON
LESLIE CAGAN	DEMIAN GABRIEL	BORIS MAJOR	DONNA SHEEHAN
JARED CHARNEY	PETER GABRIEL	DANIEL MARRACINO	JACKIE SHEELER
NOAM CHOMSKY	JOSE GAMBOA	TIM MATSUI	GERRIT SIEVERT
AARON COHEN	ARUN GANDHI	JOSEPHINE MECKSEPER	LESTER SLOAN
ANDREW JONATHAN COLE	CHET GORDON	SASHA MERET	SUSAN SONTAG
WARREN COLISON	MONIKA GRAFF	PETER MEITZLER	TED SOQUI
JENNIFER COLLINS	SABINE GRAMMERSDORF	ISAAC MENASHE	SANDRA SPANNAN
DAVID CORTRIGHT	RICHARD GREENE	MARCELLO MONGARDI	CHRISTOPHER SPRINGMANN
KELLY CROW	JANE HAHN	ILEANA MONTALVO	BOB STEIN
LISA CUNNINGHAM	KATJA HEINEMAN	MICHAEL MOORE	ANDREAS STERZING
PETER CUNNINGHAM	CINDY HELLER	GARY MOSS	KEN STEWART
BOB DAEMMERICH	P.J. HELLER	ADRIAN MUELLER	RUARIDH STEWART
CRAIG DAMRAUER	DAGMAR HELSBERG	KIRA OD	BARBARA TAUB
NIELS DAMRAUER	BARRY HOGGARD	CAMILLE PAGLIA	THE IMAGE WORKS
SONDA DAWES	MARILYN HUMPHRIES	LINA PALLOTTA	OLAFUR THORDARSON
	PETER HVIZDAK	ROMMEL PECSON	MANUEL TOSCANO

DAMIAN TOTMAN
WENDY TREMAYNE
PATRICK TYLER
TODD VAN STEENHUYSE
GEORGE WALDMAN
MARC WEAVER
AMY WENTZ
JIM WEST
DROR YARON
NEREO ZAGO
STEFANIA ZAMPARELLI
YOLANTA ZAWADA
STEVEN ZEITLIN
RICHARD ZIMMERMAN
ZUMA PRESS

SPECIAL THANKS TO

ABSOLUTEARTS.COM
ADBUSTERS
ELOISE ALEMANY
MARK ANTMAN
AUTODAFE.ORG
BARINGWITNESS.ORG
DAPHNE BEAL
MINNIE BERMAN
CLAUDIA BODIN
SVEN BODIN
CHRIS BOOT
LESLIE CAGAN

ANDY CAPELLI
NIGEL COXHAGAN
DEVIKA DAULAT-SINGH
BILL DOBBS
MATTHEW DUNTEMAN
ANNIKA EKDAHL
KATRIN ELIA
PETER FELFE
FRANCESCA FERRETTI
JOSE DANIEL FIERRO
FULVIO FORCELLINI
ANDREW FREMONT-SMITH
FLORIAN FRITZSCHE
PETER GABRIEL
URS GÄGAUF
JUSTIN GOLDBERG
CHRISTIANE GUDE
JULIA HASTING
CINDY HELLER
I-D MAGAZINE
INDYMEDIA.ORG
MIGUEL ANGEL INVARATO
RAMSEY KANAAN
SVETLANA KATZ
SUJIN KIM
NICK LEIBER
RAYMOND LORETAN
DEESH MARIWALLA
KYLIE MATULICK
ALESSANDRA MAURO

MARLENE McCARTY
MAME McCUTCHIN
FRANZISKA MING
MICHAEL NAUMANN
EMILY OBERMAN
ALINE OZKAN
JASON POLLOCK
RADIO POPULARE
MARK RANDALL
REBELLION.ORG
EDITH ROSA
FLAVIA SARAVALLI
TINA SCHELHORN
THORSTEN SCHMIDT
AMY SCHOLDER
LUCA SELVI
DONNA SHEEHAN
GERRIT SIEVERT
CARLOS SLINGER
FRANK SOUSA
LYLE STAFFORD
ZIV STEINBERG
RICK STERLING
SYLVIA STEWART
THE NOBEL FOUNDATION
SEAN TRACY
CRISTIANO VALLI-PASSATEL
JOSEF VEROVIC
WNYC
WSWS.ORG

WITH SUPPORT FROM

BARINGWITNESS.ORG
CONTRASTO IMAGES
LUKAS FITZE
FOTOGRAFOS Y PERIODISTAS
POR UN MUNDO SIN GUERRAS
FOTOTECA DE CUBA
ARUN GANDHI
JEFF LANGENDORFF
GALERIE LICHTBLICK
GOETHE INSTITUT
HELLO [ZH]
ICON IMAGES PTY LTD
IMAGESAGAINSTWAR.COM
LAIF IMAGES
LOOKAT PHOTOS
MASTERPIECE PRINTERS
M.K. GANDHI INSTITUTE
FOR NONVIOLENCE
KYRIL MOSSIN
NBPICTURES
PHOTOINK
PLAKATE GEGEN DEN KRIEG
SITE4VIEW
THE IMAGE WORKS
UNITED FOR PEACE
AND JUSTICE
WORLD STUDIO
ZUMA PRESS

Afterword

If you go to one demonstration and then go home, that's something, but the people in power can live with that. What they can't live with is sustained pressure that keeps building, organisations that keep doing things, people that keep learning lessons from the last time and doing it better the next time.

NOAM CHOMSKY AUTHOR AND PROFESSOR OF LINGUISTICS

BERLIN
GERMANY
FEBRUARY 2003
PHOTO BY
NANA YURIKO

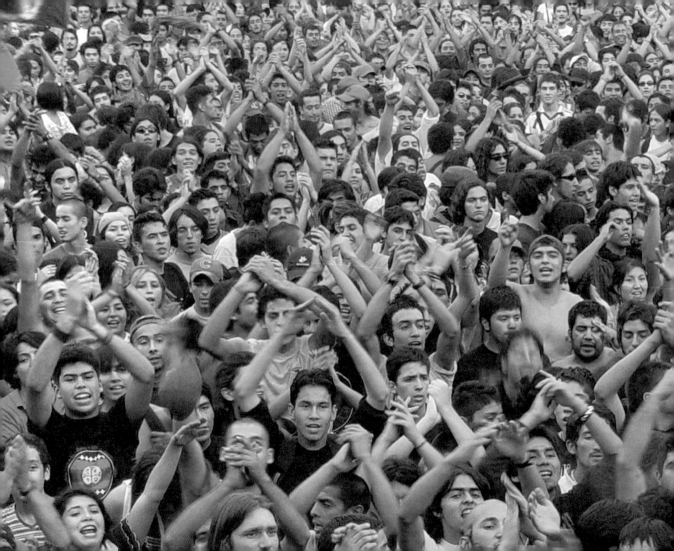